# AMERICA GOES TO WAR

## BRUCE CATTON

MJF BOOKS

NEW YORK

Published by MJF Books
Fine Communications
Two Lincoln Square
60 West 66th Street
New York, NY 10023

# Contents

# America Goes to War

# Introduction

Iᴛ ɪs perfectly possible that we are spending a little too much time nowadays in talking about the American Civil War.

It compels our attention, to be sure. As an historical pageant it still has power to stir our emotions; as a fearful object lesson in the dire things that can happen when our political machinery breaks down, it continues to be worth detailed examination; as an example of the tragic price we have paid for an expanded ideal of the worth of human unity and freedom, it deserves all the attention we can give it. Yet we seem to be transforming it into a conversation piece. More and more it is being looked upon as a mine of source material from which books—best-sellers, and otherwise—radio shows and television dramas can be made. It is becoming to us, what it never was to the people who had to take part in it, something romantic, a bright and colorful splash in the center of the slightly drab story of this country's nineteenth-century development. It is a museum piece, replete with old-fashioned flags, weapons, uniforms, and people, tinkling with sentimental little songs, set off by heroic attitudes, a strange and somehow attractive never-never land in which our unaccountable ancestors chose to live for four picturesque years.

It does no particular harm, to be sure, for us to look at it in

that way, although a good many of the participants in the Civil War might well turn over restlessly in their graves if they could know what we are doing with it. The only real trouble is that in romanticizing the Civil War in this way—in looking on it as, essentially, something that we contrived in the high and far-off times for our own amusement—we are missing the real point of it. And the real point is a matter that we can very profitably meditate on for a time, because it still has a lesson for us.

For the Civil War is not a closed chapter in our dusty past. It is one of the great datum points in American history; a place from which we can properly measure the dimensions of almost everything that has happened to us since. With its lights and its shadows, its rights and its wrongs, its heroic highlights and its tragic overtones—it was not an ending but a beginning. It was not something that we painfully worked our way to, but something from which we made a fresh start. It opened an era instead of closing one; and it left us, finally, not with something completed, but with a bit of unfinished business which is of very lively concern today and which will continue to be of lively concern after all of us have been gathered to our fathers. Forget the swords-and-roses aspect, the deep senti-mental implications, the gloss of romance; here was some-thing to be studied, to be prayed over, and at last to be lived up to.

As the war drops farther and farther into the past, it be-comes clearer that in an incomprehensible way—almost as if we did something without quite intending to—we won some-

thing prodigious. There was a victory there: not just the legendary victory of North over South, but of democracy itself over a fatally constrictive limitation—a limitation, by the way, in which the North had just as big a share as the South. The victory was achieved clumsily, at dismaying cost, without full comprehension of its true meaning, and it may indeed be true that what was won might have been won without bloodshed, if the men of the 1860's had been wiser and more patient and tolerant than anyone could logically expect them to have been. No matter; in the end something profound was accomplished.

We are not really a military people in America, yet now and then we do make war with unbridled energy and determination. Here was the war that went closer to the bone and left a deeper imprint on the national spirit than any other war we ever fought. How did we approach it, how did we fight it, and what did we do with the baffling combination of triumph and defeat with which the war left us? Despite all that has been written about the Civil War, these questions still need further exploration.

The papers that follow are derived from a series of lectures delivered at Wesleyan University in the spring of 1958. Much of the material in these lectures was taken from some of my own earlier work; it is offered here, in a different context, as a tentative effort to suggest some of the lines which that exploration might take.

# The First
# Modern War

THE Civil War was the first of the world's really modern wars. That is what gives it its terrible significance. For the great fact about modern war, greater even than its frightful destructiveness and its calculated, carefully-applied inhumanity, is that it never goes quite where the men who start it intend that it shall go. Men do not control modern war; it controls them. It destroys the old bases on which society stood; and because it does, it compels men to go on and find the material for new bases, whether they want to do so or not. It has become so all-encompassing and demanding that the mere act of fighting it changes the conditions under which men live. Of all the incalculables which men introduce into their history, modern warfare is the greatest. If it says nothing else it says this, to all men involved in it, at the moment of its beginning: Nothing is ever going to be the same again.

The Civil War was the first modern war in two ways, and the first of these ways has to do with the purely technical aspect of the manner in which men go out to kill one another. That is to say that it was a modern war in the weapons that were used and in the way in which these affected the fighting.

On the surface, Civil War weapons look very old-fashioned; actually, they foreshadowed today's battles, and there are

important parts of the Civil War which bear much more re-
semblance to World War I than to the Napoleonic Wars or
to the American Revolution. Modern techniques were just
coming into play, and they completely changed the conditions
under which war would be waged.

Consider the weapons the Civil War soldiers used.

The infantryman's weapon was still spoken of as a musket
—meaning a muzzle-loading smoothbore—and yet, by the
time the war was a year or more old, nearly all infantrymen
in that war carried rifles. These, to be sure, were still muzzle-
loaders, but they were very different from the "Brown Bess"
of tradition, the weapon on which all tactics and combat for-
mations were still based.

With the old smoothbore, effective range—that is, the range
at which massed infantry fire would hit often enough to be
adequately damaging—was figured at just about one hundred
yards. I believe it was U. S. Grant himself who remarked that
with the old musket a man might shoot at you all day, from
a distance of one hundred and fifty yards or more, without
even making you aware that he was doing it.

The point of infantry tactics in 1861 is that they depended
on this extreme limitation of the infantry's effective field of
fire. A column of assault, preparing to attack an enemy posi-
tion, could be massed and brought forward with complete
confidence that until it got to comparatively close range noth-
ing very damaging could happen to it. From that moment
on, everything was up to the determination and numbers of
the attackers. Once they had begun to charge, the opposing

line could not possibly get off more than one or two shots per man. If the assaulting column had a proper numerical advantage, plus enough discipline and leadership to keep it moving forward despite losses, it was very likely to succeed.

The assaulting column always went in with fixed bayonets, because any charge that was really driven home would wind up with hand-to-hand fighting. And if the assailants could get to close quarters with a fair advantage in numbers, either the actual use of the bayonet or the terrible threat of it would finish the business.

Artillery, properly massed, might change the picture. The smoothbore field pieces of the old days were indeed of limited range, but they very greatly out-ranged the infantry musket, and if a general had enough guns banked up at a proper spot in his defensive line he could count on breaking up a charging column, or at least on cutting it open and destroying its cohesion, before it got within infantry range. The antidote to this, on the part of the offense, was often the cavalry charge: massed cavalry squadrons could come in to sabre the gunners—which was what the British cavalrymen tried in the charge of the Light Brigade—and make the defensive line something that could be left to the foot soldier and his bayonet.

Up to 1861, all the intricate bits of infantry drill which the recruits had to learn, and all of the professional thinking of the generals who directed their movements, were based on weapons of limited range and tactics of rather personal assault.

Then, suddenly, the whole business went out of date, just because weapons had changed.

*"...subjected to killing fire by sharpshooters"*

The rifled Springfield or Enfield was a very different arm from the old smoothbore. It looked about the same, it was still a muzzle-loader, and today it looks just as much like a museum piece. But it had ever so much more range and accuracy, and it completely changed the way in which men fought.

With the Civil War rifle a good marksman could hit and kill an opponent at somewhere between half a mile and a mile. The weapon's effective range, of course, was a good deal less than that, but an infantry line could still inflict destructive

**17**

fire on its opponents at two or three times the distance that was possible with the old smoothbore. A decisive engagement could, and often did, take place with the opposing lines more than a quarter of a mile apart. At Antietam, according to an account written after the war, a veteran in the Army of the Potomac said that his unit and a Confederate unit got into action at close quarters; and this, he wrote reflectively, was one of the few battles in all the war in which he actually saw his enemies. Most of the time, "the enemy" was simply a line of snake-rail fence or a grove of trees or a raw length of heaped-up earth, from which came clouds of powder smoke and a storm of bullets. To see the other fellow as a recognizable human being was actually rather unusual—so much so that this veteran noted the fact, when it did happen, in his post-war reminiscences.

All of this meant that the old manner of making an attack was no longer good. To mass an assaulting column and drive it in with the men moving elbow to elbow was simply to invite destruction. It did work now and then, to be sure, if there were especial circumstances to aid the offensive, but under ordinary circumstances it did not work at all. Lee learned this lesson at Malvern Hill, and again at Gettysburg—bear in mind that in the climactic assault of July 3, the attackers outnumbered the defenders at the point of contact by nearly three to one—and Burnside learned it at Fredericksburg; and the lesson was painfully impressed on the mind of U. S. Grant at Cold Harbor.

Things changed for the artillery and cavalry, too. By the

18

middle of the Civil War, artillery that was massed in a defensive line along with the infantry was subjected to killing fire by sharpshooters. Its old advantage was pared down sharply. Many striking things were indeed done by brave gunners who moved their pieces into the front line, and soldiers like John Pelham and Hubert Dilger showed an amazing ability to use their guns at close range; but, in the main, artillery suffered intensely from the infantry's increased range of fire, and the artillerist dreaded infantry fire a good deal more than he dreaded counter-battery fire.

Things were even worse for the cavalry. It became nothing short of suicide for cavalry to attack formed infantry, or artillery with infantry support, and it was rarely even tried. Cavalry became less and less a combat arm, in major battles, although of course it remained extremely important because of its use as a scouting arm and as a means of screening an army's movements.

It took the generals a long time to adjust themselves to the change which had occurred while the war was going on. Many things about Civil War battles which are otherwise inexplicable become clear enough when the sudden modernization in weapons is taken into account. The repeated, disastrous frontal assaults, the frightful toll of casualties, the fact that a hard battle often left the victor too mangled to make an effective pursuit, the final turn to trench warfare—all of these things simply reflect the fact that the weapons which the soldier used in the Civil War had completely changed the conditions under which he could use them. Many of the tragedies

and apparent blunders in that war came simply because the generals were trained to tactics which were worse than useless. For all of its muzzle-loaders, its dashing cavalry actions, and its archaic artillery, the Civil War was nevertheless a modern war.

But it was more than just a matter of weapons. Much more important is the fact that the mental attitude of the two governments involved—which of course is to say the mental attitudes of the opposing peoples themselves—had that peculiar, costly, ruthless cast which is the great distinguishing mark of modern warfare.

Neither side in the Civil War was prepared to stop anywhere short of complete victory. In the old days, wars had been formalized; two nations fought until it seemed to one side or the other that it would not be worth while to fight any longer, and then some sort of accommodation would be reached—and, in the last analysis, nothing would have been changed very much. But in the Civil War it was all or nothing. The Southern States wanted absolute independence, and the Northern States wanted absolute union; once a little blood had been shed, there was no half-way point at which the two sides could get together and make a compromise. So the stakes were immeasurably increased, and this too affected the way in which men fought. If you are fighting a total war, the enemy's army is not your sole target. What you are really shooting at is his ability to carry on the fight, which means you will hit him wherever you can with any weapon that comes to your hand.

Probably it is this more than any other single thing that is the distinguishing mark of modern war: anything goes. The old "rules of civilized warfare" which loom so large in the textbooks simply disappear. Making war becomes a matter of absolutes; you cannot stop anywhere short of complete victory. Your enemy's army remains one of your targets, to be sure, but if you can destroy the social and economic mechanism which supports that army, and thereby can cause the army itself to collapse, you have gone a long way toward reaching your goal.

Consider for a moment the logical implications of this attitude. Ultimately, it is nothing less than the road to horror. It obliterates the moralities and the restraints which the race has so carefully built up through many generations. If it has any kind of rational base, the rationale is nothing much loftier than a belief that the end justifies the means. It can—and does—put an entire nation at the mercy of its most destructive instincts. What you do to your enemy comes, at last, to be limited not by any reluctance to inflict pain, misery, and death, and not by any feeling that there are limits to the things which a civilized people may do, but solely by your technical capacity to do harm. Without suffering any pangs of conscience, the group becomes prepared to do things which no single member of the group would for a moment contemplate.

By present-day standards, this process was not carried very far in our Civil War, but the genesis was there. The thing that makes modern war so appallingly frightful is not so much the hideous things which in our sublime innocence

we call "weapons" as it is the development of an attitude which makes the unlimited use of those weapons something that is taken for granted. This attitude affected not only the way in which the Civil War itself was fought but the results that came out of the war.

This dawning notion of all-out war changed the way in which the Union soldier, for example, fought. He quickly came to see that anything which hurt the Confederacy's ability to carry on the war brought Northern victory just that much nearer. It "paid," for instance, to tear up railway lines in the South, to destroy iron foundries and textile mills and machine shops, to cut off the sources of raw material which enabled the Confederacy to maintain the fight. It very soon became apparent that it was necessary—using that word in its military context—to cripple the South's ability to feed its civilians and its armies. The farmer's property, in other words, was a military objective; to destroy barns and corn cribs, to drive off herds of cattle and hogs, to kill horses and mules—these acts became definite matters of military desirability. If a state or a section whose pork and corn and cotton enabled the Confederacy to fight were reduced to destitution, the Confederacy was that much weaker and hence that much nearer final destruction.

So we got, in that war, immense destructive raids which had much the same justification that the air raid has today. From sending a Sherman through Georgia, with the avowed objective of destroying that state's productive capacity, or from sending a Sheridan down the Shenandoah Valley under

instructions to reduce that rich granary to a condition under which a crow flying across it would have to carry his own rations—from doing that to dispatching a flight of bombing planes to reduce a manufacturing city to smoking rubble is only a step. Modern war began to take shape here in America in the 1860's: and the agonizing uncertainty under which all of us have to live today is, I suppose, a part of our atonement.

In any case, fighting that kind of war leads you to objectives you had not had when the fighting began. This is exactly what happened in the Civil War. The Union soldier, invading the South, had as one of his objectives the destruction of Southern property. The most obvious, easily-removed piece of property in all of Dixie was the Negro slave. Even the Northerner who believed in slavery came to see that, and he came to see it quickly. The mere fact that he thought the black man ought to be a slave led him to understand that this slave, this bit of strangely animate property, was an asset to the government that was trying to destroy the Union. Other kinds of property were to be destroyed. This particular kind could not exactly be destroyed—after all, it was somehow human—but it could be taken away from its owners and thereby rendered useless.

It took the Northern armies only a very short time to learn this lesson. As soon as they had learned it, they began to take the institution of chattel slavery apart, chattel by chattel, not because they had anything against it but because they wanted to win the war.

Bear in mind, now, that most of this work was done by men

who had no intention whatever, when they enlisted, of making war to end slavery. Slavery was killed by the act of war itself. It was the one human institution on all the earth which could not possibly be defended by force of arms, because that force, once called into play, was bound to destroy it. The Union armies which ended slavery were led by men like Grant and Sherman, who had profound sympathies with the South and who had never in their lives shown the slightest sympathies with the abolitionists. But they were also men who believed in the one great, fearful fact about modern war—that when you get into it, the guiding rule is that you have to win it. They made hard war, in other words, and hard war in the 1860's meant the end of human slavery.

So Grant and Sherman led armies down through Tennessee into the deep South, striking hard as they went. They struck slavery simply because it was in the way; striking it, they gave it its death blow.

It is interesting to note that along with all of this the Northern soldiers who destroyed slavery came, almost in spite of themselves, to see that the slaves whom they were liberating had claims on their own humanity. The Federal soldier who went South was moving into a hostile land, where he could count on having the enmity of everyone he encountered. Yet in all of this he quickly discovered that he had allies—black folk, who had only the vaguest understanding of what the war was all about but who did somehow see that these heavy-handed young men in blue uniforms were on their side . . . or, if not exactly on their side, at least against their masters, against the

24

system which held them in subjection and numbered them with the ox and the mule as animate chattels. The Federal who wanted to know where Southern armies were and what they were doing had only to ask the nearest Negro; to the best of his knowledge—which usually was pretty limited—the Negro would faithfully tell him. The Federal who had got separated from his command and wanted to find his way back would go to the slave as an ally, and the slave would help him. The Northern boy who had managed to escape from a Southern prison and who, from the bottom of Georgia or South Carolina, sought to tramp the weary miles back to a Federal army camp, knew that the first Negro cabin he came to would be a haven of refuge, a place where he might get something to eat concealment, a chance to rest, and guidance on his perilous way.

Seeing all of this, the Northern soldier at last came to see that these black folk who were somehow on his side were not just stray bits of property; they were people, people who would do him a good turn if they possibly could, friends on whom he could call in the deepest pit of danger or hardship.

When the Northern government began to fight the Civil War it explicitly disavowed any intention of making war on slavery. By Presidential pronouncement and by specific act of Congress it stated that it was fighting to restore the Union and to do no more than that; the "domestic institutions" of the individual states—meaning slavery—were not involved at all. Yet the mere act of fighting the war killed that program in little more than one year. By the beginning of 1863 the

Northern government had proclaimed the emancipation of slaves. The war now was being fought for union *and* for freedom—a most substantial broadening of its base. And this change had come about, not especially because anyone had done a lot of hard, serious thinking about the evils of slavery, but primarily because the change had to come if the war was to be won. The war itself had enforced the change. It had done so because it was, in the strictest sense, a modern war—a war of unlimited objectives and of unpredictable results.

If you are looking for modern parallels they are not hard to find. Consider what happened in World War II—a war which, borrowing a phrase from the very heart of the Civil War itself, we announced would be fought until the enemy had made an unconditional surrender. We went into it for a variety of reasons, I suppose, just as the reasons for any war are very complex, but principally because the driving, expansive force of the Axis nations had become an intolerable threat to our national security. We fought the war and won it—and today we find ourselves compelled to worry about such things as the rights of colonial peoples, about the way in which the teeming millions of Asia and Africa may finally come to have a freer, happier life, about the whole system by which the intricately organized family of man is to order its social and economic relationships, about the true meaning of our ancient ideals of freedom and justice and democracy. We had not bargained for all of this when we began to make war. The war itself, and all that came with it, compelled us to pay heed to it.

26

# The First Modern War

So the Civil War, which began as a war to restore the Union, ended as a war to end human slavery. It was fought to a conclusion, the whole fabric of the Southern Confederacy dissolved in smoke, slavery ceased to exist—and it is at this point that we usually fold our hands piously, announce that a great forward step had been taken, and consign the Civil War to the musty ledgers of history. It *ended*—at Appomattox, with the surrender of the last armed Confederate, with the capture of Jefferson Davis, or where you please; after which we would go back and pick up the old threads where they had been interrupted and get on with the business of being Americans.

The only trouble with that point of view is that after a modern war you do not "go back to" anything at all. The mere act of war compels you to face the future, because war always destroys the base on which you have been resting. It is an act of violence which—whatever its dreadful cost, whatever its insane wastage of life and treasure—means that in one way or another you are hereafter going to do something different from what you have done in the past. The Civil War was a beginning, rather than end, simply because it knocked out of existence, forever, one of the things on which American society had been built.

# The Politics
# of War

WE TEND to think of the past, usually, in stereotypes. One particular aspect of a great event will hold our attention until we see the entire event in terms of that one aspect. This is especially true of a great war. The generals and the armies and the fearful, dramatic things they do catch and hold the eye. They are more exciting and compelling than anything that happens in time of peace, and we are very likely to look at them with such fixity that we see nothing else. We give our wars, in other words, a straight military interpretation. They become added chapters in our history, seemingly not connected with the main current of national life; it is as if a special set of rules applied in war time, forcing the acceptance of values that are not ordinarily applied, and calling for a new sort of behavior and an entirely different sort of leadership.

This is especially true in the case of our Civil War. It has become pre-eminently a military narrative. We hear the beat of drums and the heavy thudding of the guns, we see the marching armies, the fog of battle smoke lies across the landscape, and we examine all of it with intense care, trying to see precisely what happened, and why it happened, on the field of battle. When we have learned all that we can learn in that respect we are likely to think that we have learned all

that we need to know. We understand that war, we feel, when we understand just how Grant captured Vicksburg, just why Lee's invasion of Pennsylvania failed, just what Sherman's campaign through Georgia and the Carolinas accomplished. The stereotype becomes fixed. The Civil War is a story of military men.

Yet if that were really the case the Civil War would not be worth much continued study. Armies are no longer organized, equipped, or used as they were in the 1860's. The tactical lessons to be derived from an examination of that war have very little meaning in terms of modern fighting. To what conceivable use, in a day when we rely on atomic explosives, on intercontinental missiles, and on motorized and heavily-armored infantry armed with automatic weapons, can we put a study of Stonewall Jackson's flank march at Chancellorsville or an analysis of the way Grant managed to capture 15,000 men at Fort Donelson? These are matters of antiquarian interest, and little more. They may now and then serve to illustrate some timeless principle of war, but they are basically matters for the military historian, or for the enthusiast who simply happens to enjoy reading about armies and battles.

But the Civil War is clearly worth a great deal of re-examination, not because it sheds light on anything soldiers may have to do in the latter half of the twentieth century but simply because it shows how the American people made their democracy work in a time of most extraordinary trial and complexity. It may help us if we forget the stereotype and look on the Civil War as primarily a political rather than a military

affair: a tragic, bloody, and infinitely costly extension of American politics.

Bear in mind, to begin with, that the war itself came because our political machinery had broken down.

There was a great dispute between the northern and southern sections of the country—extremely complex, but revolving somehow about the existence in the cotton belt of the institution of chattel slavery—and this dispute had been central in American political life for a quarter of a century. It was argued, debated, and made the subject of valiant efforts at compromise, and none of these had disposed of it. It became, finally, something that the ordinary processes of politics could not handle, and the nation broke in two. To most Southerners, I suppose, this breaking in two looked like nothing more than a simple agreement to disagree; to most Northerners, it looked like an attempt to destroy the very basis on which the American democracy had been built; and finally, being utterly unable to settle the matter politically, the two sections tried to settle it by force of arms.

Yet the military effort which was now to be made had a political base all the way through. In the South the very first step was, not a resort to arms, but the calling of conventions, the adoption of a constitution, and the creation of a brand new government, complete with a president, a congress, an elective system, and a body of laws. In neither North nor South, throughout the four years of war, was an election missed nor were election results disputed. The mechanics of self-government went on in both nations without serious interruption.

Nor was there ever any real question, in either section, of a suspension of political action in favor of a dictatorship. Both Abraham Lincoln and Jefferson Davis took to themselves, during the progress of the war, extraordinary powers which they had not quite contemplated taking when the war began, but despite the charges made by angry opponents—charges which, in themselves, were no more than a feature of continued political activity—neither man became a dictator, and neither side was ever prepared to turn the controls over to a military man. One of the striking features of the war, indeed, was the way in which the ancient American doctrine that the elected official has supreme control over the soldier was always upheld.

Finally, each president had to make his war-time leadership and control an essay in politics rather than in military leadership. This now and then did lead to grave problems, and occasionally it contributed to military disaster, but the rule held good throughout. The President of the United States—and this of course was true also of the President of the Southern Confederacy—may in time of war be the commander in chief of all of the armed forces, with direct responsibility for their best use, but if he is to succeed he has to succeed as a politician.

It may be useful to consider in some detail the way in which Lincoln handled himself in those shattering years of crisis.

It is often remarked that Lincoln technically was very poorly prepared for his role as commander in chief. He had had no professional military training whatever. His own military experience had been of the sketchiest, confined to service in a

*"...an essay in politics rather than military leadership"*

raw volunteer company, which saw no combat service, in the Black Hawk war. He had been a politician all of his life, and he found himself commanding one of the largest armies in history in a war of vast magnitude.

Lincoln approached his war role as a politician. He "played politics," so to speak, with the command of the army. The

implication usually is that the war would have been won more quickly, and would have gone a good deal more smoothly, if things could only have been different.

I would like to suggest that Lincoln followed the right course. Political management of the Federal armies during the Civil War certainly led to many difficulties, but it also brought many advantages.

Politics is somehow supposed to be a bad word. We are a political people; we live by politics, and we turn to politics for our leadership—as a matter of fact we are constantly wagering the life of our democracy on the belief that politics is an invaluable instrument whose use we completely understand. Yet the word politician has a shady connotation, and we tend to feel that the art of politics itself is somehow unworthy of a man who hopes to qualify as a great leader and a great statesman.

Now by "politics" I mean the plain, ordinary, every-day politics of the kind we are all familiar with—the kind that is played, year in and year out, in the city hall and the county courthouse, as well as in the national Capitol and the White House itself; that queer, illogical exercise in human leadership which stirs lofty idealism up with the grossest materialism and gets good results a little oftener than there seems to be any good reason to expect.

Bearing in mind that that is just what I mean by "politics," I would like to state my thesis: Lincoln, and the Federal government which he controlled, did play politics with the military phase of the Civil War.

That was partly what was wrong with the Northern conduct of the war. But at the same time that was very largely what was right with it. The good and the bad came together, as they usually do in politics, and in the end the good greatly outweighed the bad.

Back of the military campaigns, the selection of generals, the choice of strategic objectives, and all the rest, the Northern leaders never once forgot that what they really had on their hands was a political problem. It was like no political problem the nation had ever seen before, to be sure; it was enormous, violent, tragic, explosive; but it was basically a political problem and in the end it was handled as one. As it happened, Lincoln had read Clausewitz; but even if he had not, he would have known without being told that war is simply an extension of politics. Especially the American Civil War.

In the beginning, of course, the big danger was that the whole problem raised by secession might be regarded as the exclusive creation, possession, and concern of the Republican party.

A month or two before Fort Sumter, a leading Ohio Democrat warned that if any effort were made to coerce the South, the Republican invaders would have to push 200,000 Ohio Democrats out of the way before they could even reach the Ohio River.

When the war began that attitude faded. The very Democrat who voiced that warning, as it happened, presently became a staunch "war governor" of Ohio. But there still lingered the possibility that the two political parties in the North

would eventually line up, simply, as a war party and a peace party. If the war was to be won, the administration had to win and hold the support of a great many people besides those who had voted for it in 1860.

All of this, to be sure, is part of the elementary A B C of the Civil War story. What is most interesting at this moment is the political device which Mr. Lincoln's government used so effectively to pull the Northern people together and get something like unity in the war effort.

That device was the institution of the Political General— the man who was given an important command in the army, not because anybody supposed that he knew anything about military matters, but simply because he had prominence and political influence which the administration wanted to enlist in support of the war.

The political general is usually regarded as the greatest single drawback to the Northern war effort. His very existence is supposed to prove that the Federal administration was stupid, heartless, and probably rather corrupt. He is supposed to have lost battles, to have prolonged the war, and to have caused the needless slaughter of many good soldiers. We are usually assured that the war would have been won much more quickly if he had never existed.

I believe that the conception of the role played by the political general in the Civil War is nearly 100 percent wrong.

I believe that the political general was an instrument the Northern government had to use if the war was to be fought successfully. To wrench Voltaire's famous remark out of con-

text, if he did not exist it would have been necessary to invent him. The government was right in appointing political generals, and, in the main, it was right in using them as it did. As an institution, and with some individual exceptions, the political general was worth all he cost and a good deal more.

In short, he was pre-eminently one of the things that was *right* about the Northern government's conduct of the war.

The 1860's cannot be judged by the standards of the more sophisticated and intricate twentieth century.

To begin with, remember that the tradition of the professional soldier with professional training was by no means as well established in the America of 1861 as it is today.

On the contrary, American tradition then tended to glorify the amateur—beginning with George Washington himself. Such military heroes as Andrew Jackson and Zachary Taylor had had no West Point training. American experience at least seemed to show that perfectly capable military leaders could come straight out of civil life.

The processes of warfare were simpler in those days than they are now, and they looked even simpler than they really were. Anyone can see, today, that to handle a modern armored division or a group of long-range bombing planes requires a good deal of highly technical training. It was not nearly as easy for a civilian in 1861 to realize that leading a division of infantry might also be a job for a technician. And, as a point of simple fact, the technician was not as essential then as he is today.

If the men of the 1860's believed that what was chiefly called

for in a general was the quality of leadership, it is easy enough to see how they might feel that way. For to a very large extent they were quite right.

No matter what system the Northern government followed in 1861 it was going to have to create large armies practically overnight. Those armies—in the beginning, at least—were going to be volunteer armies. Nobody was going to be made to come in. Everybody had to be asked.

Not to dwell on the point unduly, the creation of the Federal armies in 1861 and 1862 was of necessity pretty much a home-spun process. Leading citizens of high and low degree organized companies and regiments, winning commissions for themselves in the process. Given the circumstances, that was probably the best and quickest way in which those new armies could be called into being.

In any case, while it was creating these armies the government also had to create generals to command them. Before we condemn the process by which those generals were created—that is, the process by which a number of unblemished civilians suddenly found stars on their shoulders—I think we have to ask what was principally required of those Civil War generals.

They had to lead troops in action, to be sure. But if they were amateurs, leading amateurs, so were the people they were going to be fighting against. There were quite a number of West Pointers around to leaven the loaf; meanwhile, it was above everything else important to get into the government's service the qualities of leadership which these eminent civil-

ians possessed—not merely the quality which would enable them to lead troops under fire, but the quality by which the people who followed and believed in these men would be brought into whole-hearted support of the war effort.

In other words, we are again reminded that it was not possible to approach the gigantic task which the Civil War presented as a straight military problem. The war was not going to be fought by professional soldiers. In the numbers required they simply did not exist, and there was no way on earth to create them. Win or lose, the war would be fought by civilians in arms—by hundreds of thousands of young men who had no military experience and no indoctrination, and who had to be brought together by some device that would appeal to their patriotism, their ideals and their youthful enthusiasm. Turned into soldiers, these men, to the very end, would display traits that would drive the ordinary professional soldier to complete distraction. They would respond to leadership, but it had to be the kind of leadership that talked their own language. In plain English, it had to be political leadership.

Yet there was a huge pitfall in this path. The war might well be a violent extension of the political campaign of 1860—of the whole political struggle which had made the decade of the 1850's the haunted, tormented decade of American history—but it could not be made a straight Republican war. There was, to be sure, an important segment in the Republican party which wanted to do it that way, but if it were, the war would inevitably have been lost. Mr. Lincoln met that problem at the very beginning, and met it in the traditional Amer-

ican way—the way of ward and courthouse politics. That is, he gave to various important people, including the leaders of the political opposition, a piece of the job.

There are parallels to this in our own time. In 1939 and 1940, when this country was preparing to go to war with the Axis powers, there was profound danger that when the war came it would be looked upon as something that belonged exclusively to the New Deal. The administration did not grant generalships to prominent Republicans, to meet this danger, but it did turn important positions in the industrial mobilization effort over to the men who had been its bitterest political antagonists, the captains of industry.

In any case, the government in 1861 commissioned many highly unmilitary people as generals and it gave them some pretty consequential commands. What did it get out of all of this?

Well—to name only a representative few—it got such generals as Fremont, Sigel, Banks, McClernand, Logan, Blair . . . and of course the one and only Ben Butler.

There is no denying that some of these men turned out to be utterly incompetent soldiers. Is saying that the same thing, however, as saying that the Lincoln administration made a terrible mistake in commissioning them? I do not think it is.

Fremont and Sigel and Butler would handicap any army, of course. But would the Federal war effort have gone along faster if better men had been in their places—*and* if the government had never had the popular support which it won by commissioning those men? Could the war have been won if

the hard core of free-soil anti-slavery men had been alienated? Was not the support of the German community essential, particularly in such a state as Missouri? Was it not necessary to carry along the War Democrats? McClernand was of no great account as a general, but he personally recruited thousands of the men with whom the Mississippi valley was opened. The support of Blair and Logan was beyond price (and, just incidentally, those two men turned into first-rate soldiers to boot).

To win the war the Northern government had to get and keep the support of any number of separate groups, factions, and classes. One of the important ways in which it got that support was through the appointment, as generals, of civilian leaders in whom the members of those highly divergent groups strongly believed.

Beyond any question, the war was made longer and more costly than it should have been by many failures on the part of Northern generals. Yet if you will study the record in the eastern theater of the war—which is where most of those expensive mistakes took place—you will presently encounter a rather remarkable fact:

The really disastrous mistakes were made by the professionals, not by the amateurs.

From first to last, the Army of the Potomac was under professionals—McDowell, McClellan, Pope, Burnside, Hooker, and Meade. Some of these generals did indeed play politics, before and after they got to high command, but not one was a political general in the ordinary meaning of the word.

There were two battles in the east which to this day stand

*". . . melancholy examples of useless butchery"*

as melancholy examples of useless butchery: Fredericksburg
and Cold Harbor. They were strictly the work of the pro-
fessionals. No political general had an important role in either
one. The greatest missed opportunities of the war, probably,
were Antietam and the Battle of the Crater. Both were strictly
the work of the West Pointers.

If the 1864 campaign of the unfortunate Army of the Po-
tomac was made more difficult by the failure of Sigel, the
political general, it was equally affected by the failure of the
professional who took Sigel's place, David Hunter. Ben Butler

failed ingloriously to take Petersburg in May, 1864, thereby helping to prolong the war; an equally expensive failure to take Petersburg occurred exactly one month later under Baldy Smith, who was a professional.

That peculiar falling-short in generalship which lengthened the war and cost so many lives simply cannot be blamed on the administration's habit of commissioning prominent politicians.

If the government had never issued one political commission, but had chosen all of its generals from the ranks of the professionals—assuming that it could have found all of them there—none of the really disastrous mistakes in the eastern theater of the war would have been averted. The record there would be about what it is now—a record of prolonged suffering, of missed opportunities, of needless bloodshed.

What I am arguing, of course, is that the Northern government was correct in seeing the war as a political problem and in adopting straight political measures in regard to it. Its use of the political general was justified. That much-maligned creature was worth more than he cost. If, now and then, in the guise of a Sickles, he staggers us, he makes up for it a moment later by appearing as a Joshua Chamberlain. All in all, given the conditions which existed in the 1860's, he was a character who had to be there if the war was to be won.

Yet if politics was what was essentially right about the Northern conduct of the war, it was also in many ways what was wrong about it. Only up to a certain point can the flexible compromises of politics be applied to the conduct of a war.

After that point, war's own grim rules apply. The Northern government went past that point and the entire country paid the price. The war became harder, longer, and more expensive than should have been the case.

In two important respects the Federal government followed political considerations which ultimately hampered its efficient conduct of the war.

The first involved the raising of new regiments.

In the beginning the system of assigning recruitment to the activities of ambitious and energetic members of the local communities worked very well. The old 1861 and 1862 regiments contained incomparable human material and, by and large, they were adequately officered. The trouble was that, even when it became ineffective, this system of raising troops was so advantageous politically that the authorities could never quite bring themselves to give it up.

The result was that there never was a real system of providing replacements for veteran regiments. Once in a while a regiment could send an officer and a few men back home to collect recruits. Very rarely, a whole regiment could go home to recruit. But that was all the replacement system there was, as far as volunteers were concerned. Throughout the war, most of the volunteers went into brand new regiments.

This had almost ruinous effects. The new men, who would have learned their grim trade fast if they had been fed into veteran regiments, had to go in as unadulterated rookies, usually under green officers, and there was a long delay before the full value of their services was obtained. Meanwhile, the

43

veteran regiments grew weaker and weaker. In the story of the Civil War nothing is more pathetic than the repeated accounts of famous regiments steadily shrinking in numbers until they at last become impotent. Because of the political advantages that could be gained through the creation of brand new regiments, the government doomed its best fighting units to a slow but steady decline.

The other respect in which politics proved fearfully expensive was in the handling of the conscription system.

The government did muster the nerve to apply the draft, after some two years of war, but it never applied it decently or honestly.

Any man whose name was drawn could escape service in one of two ways: he could pay a flat commutation fee of $300, which exempted him unless and until his name was drawn again—or he could hire a substitute to go to war for him.

The fruits of this system were almost incredible. Of 88,000 men drafted in New York in the fall of 1863, just 9,000 finally went into the army. More than 52,000 simply paid their commutation fees. The rest hired substitutes.

This created the fantastic institution of the substitute broker —the man who, for a fee, would find a substitute for any man who wished to hire one. Some of these brokers may have been relatively honest men, though I have seen nothing in any contemporary account to make me think so; most of them operated on the level of the worst waterfront crimps in the days of the Shanghai passage.

During World War II there was a common gag: the army

doesn't examine your eyes—it just counts them. The substitute brokers did not even do that. All they asked was that a man be able to walk. They made such profits that they could usually bribe the enrolling officers. We find the medical director of the Army of the Potomac complaining, in the winter of 1864, that many recruits received in camp were complete physical wrecks. Of 57 recruits sent down to one New York heavy artillery regiment, he said, 17 were so completely disabled that even a layman could see it—that is, they were hump-backed, or they had only one arm, or they were in the last stages of tuberculosis, or they were out-and-out dribbling idiots. In March of 1864 the cavalry corps of the Army of the Potomac reported that 32 percent of its recruits were on the sick list when they reached camp and that 8 percent of the lot were permanently crippled.

Hand-in-hand with the substitute business went the high bounty system, which in some ways was even worse. Under this system cities, towns, and states bid against one another for recruits, and in the latter part of the war a man could easily collect a thousand dollars for enlisting. No better system could have been devised for getting the wrong kind of men into the army. In the final year of the war a recruit camp was usually conducted like a penitentiary. It had to be: it had pretty much the same class of occupants, and they were just about as reluctant to remain. You can read of places where new recruits were commonly made to wear the ball and chain; of men who had enlisted ten or a dozen times, collecting the bounty each time and then deserting at the first opportunity in order to

re-enlist somewhere else; of veterans in famous regiments complaining that their ranks were being filled up with out-and-out criminals, who would sit around the campfire (as long as they bothered to remain in camp) and brag about their exploits as safecrackers or cutpurses.

The overwhelming majority of men thus brought into the army were of course wholly worthless as soldiers. Those who did not manage to desert earlier almost invariably faded away the moment a regiment went into action. When the Army of the Potomac broke Lee's line at Petersburg on April 2, 1865, the 61st Pennsylvania took 500 men into action—200 of them veterans, 300 newly-arrived substitutes. In the charge the veterans carried the Confederate works, while all of the substitutes vanished and were never seen again. Writing about it after the war, the brigade commander wrathfully declared that "the 200, in my opinion, all should have large pensions, and the 300 should all have been shot or hung."

What all of this adds up to was that for purely political reasons the government condemned its armies to fight under the handicap of an unjust and utterly defective draft act. People did not like the draft. It seemed that it would be politically risky to make it an honest, workable instrument for maintaining the strength of the army. Consequently the draft act was never reformed. I suspect that in the Virginia theater, at least, eight or nine months of war can be charged directly to the commutation fee, the substitute broker, and the high bounty system—and, ultimately, to the political cowardice that created these institutions.

So the accounts appear on both sides of the ledger. The conduct of the Civil War was enhanced by politics, and it was also thwarted by politics. Lincoln recognized his task as a political problem—he knew perfectly well that democracy does not work in spite of politics, but because of politics—and although he finally solved that problem at colossal expense he did solve it. What was wrong about politics in Mr. Lincoln's time is still wrong—but what is right is still right.

Politics works at a high price and operates through the lowest common denominator of what exists in the hearts of the people—which means the hearts of you and me. There is cowardice there, often enough, and meanness, and petty selfishness, and politics has to take them into account. Yet those same hearts contain courage and nobility and faith, and in the last analysis the good outweighs the bad. Our belief in democracy itself is nothing less than a belief that good will outweigh the bad. We live by politics. We do various hopelessly inefficient things, we waste enormous amounts of strength and energy, we compromise everything but the underlying ideal—but because at bottom there is an undying devotion to that ideal, we keep on living.

Our system of government has a loose-jointed quality—it is flexible enough to stand extreme stress and strain. It never gets rigid, and therefore it never quite breaks under pressure. Often enough, the political system by which our democracy works brings out, or seems to bring out, the worst in people; the saving grace is that in times of crisis it also brings out the best, and the best is pretty good.

# The Citizen Soldier

THE American soldier has been much the same, probably, from the Revolutionary War down to the present day. He reflects the national character, and the national character has not changed a great deal. Weapons, tactics, strategic concepts, equipment—all of these may have changed enormously; yet the human material of which American armies are made is today very much as it was generations ago. As the battle record of many wars attests, this material has uniformly been pretty good.

Yet the ways in which this material has been used have undergone many changes. It may be instructive to note some of these changes, to see what happened in an earlier, more informal period, and to reflect on some of the lessons which can be deduced.

The first thing that strikes one, I think, in looking at the Civil War soldier, is that he was the product of a rather unsophisticated age. He did have his moments, to be sure, in which he demonstrated that he knew his way around in the workaday world; yet the world in which he knew his way around was a little less highly developed than our own. It was not mechanized. It lacked the ineffable advantages of radio, television, and moving pictures. Its cities were smaller, its

*"...those youthful innocents"*

country towns were more remote and genuinely rural, and a larger proportion of its people lived on farms, which, in turn, were much closer to the frontier than anything we have today. The Civil War soldier spoke for that environment. He had a few traits which are not quite paralleled today, among which is a quality that I can only describe as a sort of youthful innocence.

I know of no better way to describe this quality than to mention a very common device which was used by teenagers in the middle west who wanted to join the army before they had reached the required age of 18. We of course have youngsters today who want to enlist at 16 or 17, but they usually

simply go to the recruiting offices, swear that they are 18, and let it go at that. The boy in the 1860's saw it otherwise. He could not tell an outright lie to his government; in his book, that somehow was wrong. What he would do, then was this: he would take a bit of paper, scribble the number "18" on it, and put it in the sole of his shoe. Then, when he was asked how old he was, he could truthfully say, "I am *over* 18."

That is a tiny thing, to be sure, and yet it is not quite the sort of thing that could happen today. It reflects a characteristic of a by-gone age; it came out of an America which, I suppose, may have been no better than today's America but which did manage to be a little more innocent.

Now what lay ahead of those youthful innocents, once they got into the army, was quite as grim and disillusioning as anything that lies in wait for today's soldiers.

When the total number of casualties caused by the Civil War are matched against the country's total population, that war emerges as the costliest, deadliest war America ever fought. More than 500,000 soldiers lost their lives, in a country whose entire population, North and South together, numbered hardly more than 30 millions. If battle losses in World War II had been in proportion, we would have had 2,500,000 men killed—exclusive of those wounded and missing. Some of the individual battles of the Civil War cost each army engaged more than 25 percent of its total numbers, including the men in non-combat details. Individual tactical units met even more appalling losses. In a surprising number of cases, a regiment might lose as many as 75 or 80 percent of the men

engaged; and the fight in which such losses were incurred might last no longer than an hour or so.

All of this took place, furthermore, in the era of muzzle-loaders. With rare exceptions, infantrymen used muzzle-loading muskets—usually rifled, but by no means invariably so—with which the best man could hardly get off more than two shots a minute. Artillery was equally primitive. Indirect fire was unheard of; the gunner had to see his target with his own eyes in order to fire at it, and shell fuses were so unreliable that it was often an even chance whether the shell he fired would burst over the enemy or over his own infantry. To all intents and purposes there were no rapid-fire guns. Land mines, known then as torpedoes, were used only in a very few cases and were no more than minor nuisances.

The contrast between the primitive nature of the weapons and the deadly character of the fighting is striking. It is worth emphasizing because it proves that that far-off war was as deadly and as frightening, for the man engaged in it, as any war that was ever fought. And what makes the case even more astounding is the fact that the system of drill and discipline which took Civil War soldiers into action had nothing like the hard, impersonal tautness with which we are familiar today. The Civil War army tended to be informal, almost slap-dash. Yet somehow it got results. Any system of discipline which would hold men together through the impact of a battle like Gettysburg or Chickamauga must have had its virtues.

So it may pay us to have a close look at the way in which the

basic tactical unit of the Civil War armies, the regiment, was brought together and led.

The very way in which the ordinary Civil War regiment was organized was an obstacle to strict military discipline. While the Federal government of course controlled the raising of troops, and had complete supervision over them once they were mustered in, the matter of raising and organizing the regiments was up to the state authorities. Most regiments, as we have already seen, were recruited locally. In the ordinary course, some citizen would be commissioned by the governor to raise a regiment. He would open recruiting offices, deputize a number of men to help him, and go about looking for volunteers. If one of his helpers brought in a substantial number, that man would possibly be rewarded with a commission as lieutenant or captain; and the man in charge of the whole effort would, of course, become the colonel. In a great many cases, the individual companies would elect their own officers; very often, the colonel himself was elected by the men.

I review this to emphasize that in the average regiment the officers were people whom the enlisted men had known all of their lives. The colonel or the major might, indeed, be a "leading citizen" of such stature that few of the recruits had ever been intimate with him, but the company officers had usually been on a first-name basis with their men for years. The same of course was true of the non-commissioned officers.

It goes without saying, thus, that the private soldier was not likely to treat his officers with any undue amount of military formality. Perfectly typical is the account of a New York regi-

ment toiling at infantry drill on a dusty field on a hot summer day. Presently one of the soldiers turned to his captain and said: "Say, Tom, let's quit this darn foolin' around and go over to the sutler's." An Illinois veteran wrote after the war: "While all of the men who enlisted pledged themselves to obey all the commands of their superior officers, and ought to have kept their word, yet it was hardly wise on the part of volunteer officers to absolutely demand attendance on such service, and later it was abandoned." An Indiana soldier was even more explicit about it, declaring: "We had enlisted to put down the rebellion and had no patience with the red-tape tomfoolery of the regular service. Furthermore, the boys recognized no superiors, except in the line of legitimate duty. Shoulder straps waived, a private was ready at the drop of a hat to thrash his commander—a thing that occurred more than once."

It is perfectly obvious that an army organized in this way required rather special qualities of leadership from its officers. In general terms, the Civil War officer led his men, not because he wore shoulder straps, but because the men came to recognize and accept him as a qualified leader. This meant, above everything else, that in battle the officer had to be absolutely fearless. Even a major general would immediately lose control over his men if they found reason to suspect his courage. From army commander on down, he had to show physical courage rather ostentatiously. If he could not do this he could not do anything.

The officer also had to realize that he was dealing with

citizen soldiers who, even after two years of war, would insist on remaining more citizen than soldier. They could be led anywhere, but they could hardly be driven at all. West Point training seemed to work two ways, in this connection. At its best, it turned out officers who knew instinctively how to induce obedience; at its worst, it produced officers who simply could not command volunteers at all.

Discipline in the Civil War armies in other words rested largely on the officer himself. It was not something he could very easily enforce; it had to come out of his own qualities of leadership. If he lacked those qualities, he had no discipline.

There were points on which the Civil War soldier simply refused to submit to restraint no matter what the source. This was especially true in respect to the matter of foraging and looting civilian property in occupied territory.

The Northern soldier was pretty much unindoctrinated, when he enlisted, and of course the same thing was true of his Southern counterpart. He usually joined up because it seemed like an adventurous, romantic thing to do, or because everyone else was doing it, or because the waving flags and the rounded periods of the orators touched some chord of patriotic feeling in his breast—or, in a great many cases, simply for fun. In the North he would say, if asked, that he was fighting to save the Union; in the South, that he was fighting to protect his homeland from invasion; but neither North nor South did the enlisted man usually bother to enlarge on this very much, and the ins and outs of secession, states' rights, chattel slavery, and so on do not seem to have

been very clear to him. In neither section was the average soldier especially concerned about the broad issues of the war, and as a general thing he was not very articulate about the emotions that pulled him into the army and kept him there after the first blush of enthusiasm had worn off.

In this the Civil War soldier was perfectly characteristic, not simply of his own time and place, but of the American soldier of all generations. During World War II some highly thoughtful newspaper editorial writers and United States senators used to become very exercised over the soldiers' apparent lack of indoctrination. When pressed as to what he was fighting for, the G. I. Joe of recent memory usually said that he was fighting simply to get the war over so that he could get back to Mom's cooking, and at the time the serious thinkers felt that this revealed a dreadful state of affairs. The American soldier, they believed and said, ought to be better indoctrinated.

Their attitude is understandable: but indoctrinated—about what? Did we, either in 1861, in 1917, or in 1942 need to tell American boys that life in America is worth fighting for? If there is one thing in America we can be sure of, it must be that there is a value in our loose, easy-going, good-natured society here that is worth everything anyone can sacrifice for it: a value that goes so deep and permeates all of life so completely that the people who are called on to do the sacrificing never need to define it or work up fine phrases about it. And it is precisely that fact, I think, that constitutes our greatest strength. We don't need to be told about the things

that matter most to us, because we are so familiar with them that we take them for granted. We live them. In World War II, remember, the truly indoctrinated soldiers were the soldiers of Hitler and Hirohito. In the end, they were the ones who got licked—licked by the very boys whose inability to define our war aims proved so disturbing to the high-minded folk back home.

The American soldier, in short, usually plays it by ear. He never really becomes very military; for better or for worse, he remains to the end a citizen in arms. In the Civil War the Northern soldier who simply said that he was fighting to save the Union and let it go at that, drew from this unadorned creed what seemed to him to be the proper logical deductions.

One of these deductions was that the Southerners with whom he was fighting were men who wanted to destroy the Union; were, in other words, traitors, to whom the worst that could happen was far too good. Figuring it that way, he resolutely refused to respect Southern farmers' rights to their chickens, hogs, green corn, fence rails, or other property. It is interesting to note that the ravages which Northern soldiers inflicted on Southern territory came much more from the impulses of the common soldier than from the orders of hard-war men like Sherman and Sheridan.

Indeed, Sherman himself, during the first two years of the war, did his best to keep his men from stealing Confederate hams and burning Confederate barns. He tried all sorts of ferocious disciplinary measures to stop it, including ordering enlisted men tied up by the thumbs, but without the slightest

success. His men simply did not feel that there was anything wrong with what they were doing. Furthermore, the regimental officers, as a rule, felt the same way the enlisted men did, and flatly refused to enforce orders against looting and foraging. It was common for a colonel, as a regiment made camp, to address his men, pointing to some nearby farm, and say: "Now boys, that barn is full of pigs and chickens. I don't want to see a one of you take any of them"—whereupon he would fold his arms and resolutely look in the opposite direction. It is equally common to read of a colonel, imposing punishment on men who had been caught looting, saying sternly: "Boys, I want you to understand that I am not punishing you for stealing but for getting caught at it, by God!"

The point of course is that Civil War discipline was never tight enough to keep the men from doing something which the men themselves believed to be justified. Sherman's orders could not be enforced, partly because the men were not disposed to obey them, and partly because the regimental officers who were primarily responsible did not try to enforce them. In broad areas of conduct the Civil War soldier tended to go his own way regardless of what the man at the top had to say.

Perhaps the most surprising part about the defective discipline of the Civil War regiment is that it nevertheless sent to the front a great many fighting regiments of amazing effectiveness.

To a large extent this was because the men did, after all, know each other well. They had a solid feeling that they could count on one another—and, no doubt, a reluctance to show

fear or hesitancy before men they had known all their lives. If a man was wounded, he knew perfectly well that even if the stretcher parties missed him some of his pals would hunt him up, if they possibly could. There was a powerful feeling of comradeship in most of those regiments, and it was a prodigious factor in battle.

In addition, many of those Civil War units built up a very high *esprit de corps*. The soldier identified himself first of all with his regiment, and he tended to be very proud of it. If his brigade or division had made a good name in some battle, he was equally proud of that. General Phil Kearny, the one-armed soldier who was killed in the summer of 1862, started something when he made all the men in his division wear a diamond-shaped patch of scarlet flannel on their caps. He did this simply in order that when he saw stragglers in the rear areas he could tell at once whether the men belonged to his outfit, but in no time at all the red patch became a badge of honor. Kearny's men felt they were something special because they wore it, and when a new regiment was assigned to the division the men in the older regiments refused to warm up to it until they had a chance to see it in battle—and, as one veteran put it, see "whether the regiment was worthy of belonging to the red diamond division." Six months later, Joe Hooker had similar patches made for each army corps in the Army of the Potomac, and before long the idea had spread to the western armies. Today's shoulder patches are direct descendants of these devices.

The eastern armies adopted the corps badge ahead of the

westerners. In 1863, when eastern troops were sent west to bolster Grant's army in front of Chattanooga, some of the westerners in the 15th Corps looked in wonder at General Slocum's 12th Corps boys, whose badge was a red star. A 15th Corps Irishman finally accosted one of the easterners:

"Are you all brigadier generals, with them stars?" he asked.

"That's our corps badge," explained the easterner, loftily. "What's yours?"

"Badge, is it?" snorted the Irishman. He slapped his cartridge box. "Here it is, be Jazus—40 rounds!"

His corps commander heard the story and promptly adopted the device; and for the rest of the war, the 15th Corps wore for its badge a replica of a cartridge box with the words "40 rounds" printed under it.

Soldiers would quickly take their tone from a commanding officer, if the officer had enough force and leadership. There was an old regular army man, General Charles F. Smith— tall, slim, straight as a ramrod, with long flowing white mustachios—who knew instinctively how to lead men in action. He showed up at Fort Donelson with a division of green troops who had never before been under fire, and he had to lead them up a hill, through tangled woods and underbrush, in a charge on a Confederate line of trenches. He stuck his cap on the point of his sword, got out in front of his frightened greenhorns, and started off. Confederate bullets began to come through pretty thickly, and Smith's men wavered. He turned about in his saddle and called out:

"Damn you, gentlemen, I see skulkers. I'll have none here.

Come on, you volunteers, come on. This is your chance. You volunteered to be killed for love of your country and now you can be. You damned volunteers—I'm only a soldier and I don't want to be killed, but you came to be killed and now you can be!"

The line went on up the hill and captured its objective. One soldier wrote: "I was pretty near scared to death, but I saw the old man's mustache over his right shoulder and I kept on going."

Discipline or no discipline, enough men would respond to that sort of leadership to put up an excellent fight.

From whatever source he got his battle morale, the Civil War soldier somehow learned how to handle himself under fire. Sometimes he had to learn the hard way, for he was often thrown into action almost totally untrained. Perhaps the best illustration of this is the battle of Shiloh, where two green armies ran into each other head-on and fought for two days.

It is almost impossible nowadays to understand how pathetically unready for battle were most of the men who were pushed into the great fight at Shiloh. A Confederate brigadier general confessed afterward that until the moment the fight began he had never heard a gun fired, nor had he ever read a book or heard a lecture on tactics. There were Confederate batteries in that battle which had never fired their guns before; ammunition had been too short to allow practice firing. Many Union infantry regiments received their muskets on the way to the field, and loaded and fired them for the first time in action.

*"...just like shooting squirrels"*

There is one revealing picture of a pea-green Ohio regiment which was in that fix, drawn up in line of battle under a heavy fire. The colonel had run for the rear at the first shock; the men were leaderless, not knowing what they were supposed to do or how they were supposed to do it, but game enough to want to stick around and find out. From somewhere there came a private soldier from another regiment. He had fought at Fort Donelson, and compared with these recruits he was a veteran. He carefully went along the firing line, showing the boys how to load these muskets and how to use them; and as he went, he kept explaining:

"It's just like shooting squirrels, only these squirrels have guns—that's all."

And the regiment stayed there, unled, and fought all day long.

Civil War officers quickly learned one thing about green troops which were shoved into battle that way. They would either run away quickly, after the first volley, or they would not run away at all. At Shiloh, a great many did run; after the battle was a couple of hours old, probably a fourth of Grant's army was huddled under the shelter of the river bank in the rear, completely leaderless and useless. But the rest stayed and fought, and few soldiers have ever fought in a more vicious battle. All military order and tactical formation were quickly lost. A battle line might contain elements from half a dozen different regiments, huddled together, somehow drawing from one another's presence the courage to stay and fight. An advance would be a rush forward by a mob; a retreat would be much the same, with the men sticking close to whoever seemed to show the qualities of leadership. We read of one Indiana lad who got a flesh wound in his arm, showed it to his colonel, and was told to drop his rifle and go to the rear. He started off, found Rebel troops in the rear, and presently came back to his colonel.

"Gimme another gun, cap," he said. "This blame fight ain't got any rear."

Some of these undisciplined private soldiers developed strong qualities, as the war wore along. In the battle of Champion's Hill, during the Vicksburg campaign, General John A. Logan, commanding a Federal division, was sitting on his horse on a hill-top, watching the fight, when a lanky enlisted

man—who seems to have been prowling around more or less on his own—sauntered up to him and said:

"General, I've been over on the rise yonder, and it's my idea that if you'll put a regiment or two over thar, you'll get on their flank and lick 'em easy."

Logan looked where the man pointed, decided that the advice was good, sent a couple of regiments over—and, as the man had predicted, won his fight.

One of the most striking things about the average Civil War regiment was the high degree of manpower wastage that afflicted it. Every regiment contained a certain number of men who would fade back to the rear when the fighting began. No colonel could count on all of his men; there was a steady leakage back from the firing line, even in the veteran regiments, from the beginning of the war to the end.

Worse yet was the toll taken by disease. Medical examinations for recruits were very sketchy. Some regiments got in without any medical examinations at all; and in any case, medical care was so imperfect that there was a steady, remorseless drain on combat strength, month after month. The Civil War regiment had a paper strength of one thousand men; the regiment that could bring as many as five hundred to the field, after six months in camp, was very lucky, and the average strength of a veteran regiment would usually be between two and three hundred. One veteran remarked that a third of a regiment's strength would usually be lost by desertion or straggling, and another third by sickness. The remaining third—the men too stout to run away and too tough to get

sick—had to do the fighting. It was right there, probably, that the loose discipline and informal organization of the volunteer army proved most costly.

Yet in the long run these odd combat organizations did what they were supposed to do. If it is possible to dredge up any number of stories revealing slipshod organization and peculiar military habits, it is also possible to show fantastic instances of solid bravery and endurance which no professional soldiers could have improved upon.

On the second day of the battle of Gettysburg, for instance, when the left end of the Union line on Cemetery Ridge had more or less dissolved, and Confederate troops were swarming up the slopes with nothing much to stop them, the First Minnesota came marching up from the rear to get into the fight. General Winfield Scott Hancock, corps commander in charge of that part of the line, saw a Confederate assault wave coming, and galloped over to the Minnesota's colonel. This colonel had been under arrest for several days; on a forced march to Gettysburg he had halted his troops, against Hancock's orders, so that they could take off their shoes and socks before fording a little stream, and Hancock had punished him for it. The colonel was feeling rather bitter about it.

Hancock pointed toward the oncoming Confederates whose battle flag was visible.

"Do you see those colors?" he demanded. The colonel nodded. "Well, take them!" said Hancock.

The First Minnesota went in, head-on. It numbered only

262 men, but it swung into line and made its fight. It stopped the Confederate charge, captured the battle flag, and an hour later it had just 47 men left—for a loss of 82 percent, which seems to have been a record for the Union army for the entire war. Next day, incidentally, those 47 who remained stayed in line and helped repel Pickett's charge.

Any military system which can produce combat units that will stay and fight after a loss of 82 percent seems to me to be a pretty good system, no matter how many surface defects it may have. The worst thing about it, of course, was that it gave the willing horse all of the load. It never controlled the stragglers and the faint-hearts. The good men got all the worst of it, and the gold-bricks mostly got off easy. But a tremendous job of fighting did get done.

The behavior of the Civil War soldier often horrified professional military men from overseas. The famous German General Von Moltke is said to have remarked that he did not find the Civil War worth study because it had been fought by armed mobs. From his viewpoint that was a proper appraisal, although I suspect that by 1864 such Civil War outfits as Lee's Army of Northern Virginia or Thomas's Army of the Cumberland could have taken on any European army of comparable size and could have tied it into knots. When Phil Sheridan watched Von Moltke's troops in action during the Franco-Prussian War he grunted that his Army of the Potomac cavalry corps could have licked the lot of them, and he may very well have been right. But the great point is that

*"...real touch of military precision"*

these Civil War armies did not follow the old-world military tradition. Like the country that bred them, they were something new—and very different.

The Civil War soldier was a quite ordinary human being rendered extraordinary by his confrontation with fate, coming to grips with something larger than himself. He never quite managed to look like a European-model soldier; incurably, he looked like precisely what he was—a civilian who had put on a uniform and taken up a weapon because there was a job to be done, but who let neither the uniform, the weapon nor the gold-braided officers who had charge of him make very much difference in his thinking or his behavior.

If he did nothing else, this soldier in blue or gray at least

66

proved something about the way Americans react in the great moments of history. He displayed heroism without indulging in heroics. Perhaps the best way to get the true feeling of him is to visit one of our Civil War battlefields—those park-like expanses of lawn and trees, with their military cemeteries where white headstones are ranked with such admirable military precision: the only real touch of military precision, I suppose, that our Civil War soldiers ever attained.

# Making Hard War

WE ARE people to whom the past is forever speaking. We listen to it because we cannot help ourselves, for the past speaks to us with many voices. Far out of that dark nowhere which is the time before we were born, men who were flesh of our flesh and bone of our bone went through fire and storm to break a path to the future. We are part of the future they died for; they are part of the past that bought the future. What they did—the lives they lived, the sacrifices they made, the stories they told and the songs they sang and, finally, the deaths they died—make up a part of our own experience. We cannot cut ourselves off from it. It is as real to us as something that happened last week. It is a basic part of our heritage as Americans.

We have paid and will pay tribute to the men who fought in the Civil War, and will commune with them as their voices reach us from the past. Although we have heard their story a great many times, it is always worth a re-telling. They were pretty good men, those old veterans of ours. Not only do we owe them something that we can never repay: they have something to say to us that is worth listening to.

I will always consider it one of the privileges of my life that I was born into a generation which still knew the Civil

68

War veterans personally. They were very old men when I was a very small boy, and it is probable that I often had a small boy's impatience with the graybeards who lived so completely in the past. And yet, as I look back, I can see that I got something beyond price from those old gentlemen.

They taught me, for instance, what patriotism is. Not that they ever actually said much about it; they were not given to striking attitudes, and I do not now remember that any one of them ever read me or anyone else a lecture on the importance of loving one's country. With them, patriotism was automatic, something one simply takes for granted, something that comes into a person along with the air he breathes. It was not rally-round-the-flag stuff, although those old gentlemen still enjoyed listening to the patriotic songs of Civil War days, and could raise thin little cheers at some of the old emotional appeals of their youth. Rather it was an unspoken, compelling attitude of mind. You grew up in this country, and enjoyed the life that was possible here; some day when you were grown, your country needed you—and no matter what it asked of you, you stepped up and gave it, and considered yourself lucky to have the chance. That was all there was to it. It was not a bad thing for a generation to grow up with.

Those old soldiers gave a special flavor to small-town life, forty years ago. I can remember one old gentleman who had been a drummer boy with the Army of the Tennessee, half a century earlier. He was a simple sort of old man, living in a little cottage on the edge of town, and on quiet summer evenings he had a way of getting out his drum, sitting on

his back porch, and tapping out the drum calls of long ago.

Probably there is nothing on earth now that is quite as silent as a small middle-western town used to be, in the pre-automobile age, in the dusk of an August evening. There might be a tree toad or two, sounding off somewhere, or a stray dog half-heartedly barking at the evening shadows, but there would be no other noise at all; and then, in the twilight, there would be the tap-tap-tap of that drum ... the drumbeats of Chattanooga, rolling through the stillness; and it used to make the half-forgotten Civil War seem very real and immediate. Words like Gettysburg and Chickamauga and Antietam and Spotsylvania Courthouse meant something to me, when I was growing up. They were magic words, with a ring to them, a drum-beat rhythm under their long syllables. That meaning they have never lost.

Now of course the Civil War veterans I knew were very aged, and they had become grave and reverend men—most of them, anyway. Somehow I got the impression that they had always been that way. To be sure, I knew they had been young, once; but the dignity, sobriety, and general upright-ness that attached to them when they were old seemed always to have been there. I suppose I got a queer picture of an army of men who never swore and never complained, who devoutly followed the flag, and remained pillars of the church every step of the way, a set of Ironsides who were completely above all human frailty.

We acquire wisdom as we grow older, and eventually I came to see that these soldiers whom I had known as very

*"... we romanticize the whole story"*

old men had been just like all other soldiers, once upon a time. That is, they were perfectly average young men, who went off to a war they did not wholly understand for a variety of reasons which they probably could not have defined; young men who disliked danger and hardship as much as anyone, who complained about their food and about discipline, straggled badly on hard marches, shirked their duty occasionally, ran away from battle once in a while—and, along with it, carried the heavy load that had to be carried if the country was to survive.

In other words, they were perfectly normal young men, who had got into something bigger than they were and did

the best they could with it. Their best turned out to be very good indeed, and if in old age they sat on the bench in front of the village store and posed as heroes they had earned the right to do so.

The only trouble is that when we look back at them we tend to see the old men on the bench rather than the young men on the march. We see the heroism but we miss the price that was paid for it. We romanticize the whole story, and if we are not careful we fall into the error of supposing that their war was not quite as grim, as hard, and as terrible as we know modern war to be.

Perhaps, with a story, I can help to get the picture back into focus. It is a story that deals with the Battle of Five Forks, which was fought in front of Petersburg, Virginia, on April 2, 1865.

This battle was the beginning of the end for Lee's famous Army of Northern Virginia. It marked the final breaking of the line Lee had held for nine long months, and sent his army off on the hopeless retreat which ended, just one week later, at the sleepy courthouse town of Appomattox. It was the final, decisive Union victory of the war—and the odd part about it is that it led to a furious argument between the two Union generals chiefly involved in the battle, an argument that had not subsided twenty years afterward.

These generals were Phil Sheridan, commander of the Union forces engaged at Five Forks, and Gouverneur Kemble Warren, who led the infantry elements involved in the battle. At the very moment of victory, Sheridan relieved Warren

of his command, denounced him bitterly and publicly, and in effect ruined his career just when the triumph had become complete.

Ordinarily, nobody quarrels with a victory. Civil War battles, it must be admitted, were uncommonly fertile ground for disagreements between generals, but most of the disagreements grew out of defeat. Here they grew out of a victory sweeping enough, one would suppose, to have satisfied even the prima donnas who led troops in the Civil War.

Why?

The surface explanation is that Phil Sheridan was just naturally a very hot-headed man. He had a temper of fabulous proportions and his grip on it was never very strong; in the heat of this particular battle he blew up, Warren was standing in the line of fire—and that was that.

But the incident has a good deal more significance than that. Actually, it highlights a problem in command; it emphasizes, that is to say, the fact that under all of its trappings of romance and interest, the Civil War was a hard war, and that it took hard men to win it. The men who, in their extreme age, dozed in the sun on the Decoration Day platforms and played the part of benign old heroes had been through something, in the days of their youth. They had been through a war, and one of the pitiless rules of war is the fact that no excuses for failure are ever any good. It is not a trade in which gentlemanly instincts are of very much use. Many generals do have them, to be sure, but underneath those instincts the successful general must also have the instinct of the driving,

ruthless perfectionist and the instinct of the killer. What happened at Five Forks brings that fact into focus.

Bear in mind that the Union Army of the Potomac, which was made up of fighting men as good as any army ever had, had been singularly unfortunate in its generals. For the most part they had been good men, gentlemen, thoughtful and considerate persons who did their best according to their lights; but none of them had ever been in much of a hurry. None of them were what we would call sluggers. Until Grant came along, they seem to have looked on war as an elaborate game played by elaborate rules. The loss of an hour, or a day or two, or even a couple of weeks, made no especial difference to anyone. In some ways, war to them was like a game of chess. They seem to have looked upon it as something that was essentially bloodless.

Now this was very bad for the private soldiers who had to serve under these generals, because this attitude meant that they were forever getting licked. For the army they were fighting against—Lee's great Army of Northern Virginia—did not suffer from those defects in command. It was led by men who saw war as red-hot combat—a business of getting in close with the other fellow and slugging until something broke. Lee, Jackson, Longstreet, and the rest were primarily fighters, men who actually enjoyed combat, men who never gave themselves or anyone under them any rest as long as their enemies were still on their feet and breathing.

Hot-tempered Phil Sheridan was cast from the same mold. Warren was not. Out of that came their famous quarrel.

Take a brief look at the background of the explosion at Five Forks.

Grant had been besieging Lee in the lines around Petersburg ever since the previous June. Slowly, bit by bit, he had been extending his lines to the west, forcing Lee to thin out his own lines to meet him, constantly threatening to curl an armed force around Lee's right flank, cutting the Confederate supply lines and compelling Lee to evacuate Petersburg, which was the final defense of Richmond. Late in March, 1865, Lee had made a despairing counter-attack in the assault on Fort Stedman. This assault was beaten off. After that the initiative was in Grant's hand and, at the end of March, Grant set out to make the most of it.

Grant sent Sheridan and approximately 10,000 cavalry out on a sweep around Lee's right flank. Sheridan moved first to the little hamlet of Dinwiddie Courthouse, well to the southwest of Grant's own left flank; from there, he had only a comparatively short distance to move, marching almost due north, to strike the South Side Railroad line and cut Lee's communications with the south.

To meet this threat, Lee detached a force of cavalry and infantry, with General George Pickett as the commander, to operate against Sheridan. Pickett established himself in the vicinity of Five Forks—which was nowhere: just a place in the dreary pine flats where the important roadways crossed—and knocked back Sheridan's cavalry when the leading mounted division went prowling forward toward the railway line.

Pickett's first blow was successful, and Sheridan had to fall back on Dinwiddie Courthouse, with Pickett following closely. The weather was bad, the roads were little better than quagmires, most of the fields were as soggy as the bottom of a millpond, and Sheridan's thrust had been blunted. Yet Sheridan realized that the temporary advantage which the Confederates had won actually represented a shining opportunity for the Federals. Lee had detached a substantial force—more of a force than, in his present condition, he could afford to lose—far out beyond his own flank. Sheridan reasoned that that force should never be allowed to get back to Lee. If the Federals moved fast, he argued, they could utterly destroy it; after that the way to final and conclusive victory would be wide open.

So Sheridan plodded off through the mud to Grant's headquarters. He had been sent out on what was, essentially, a raid: now if Grant would send infantry to stiffen his cavalry, said Sheridan, this could be turned from a raid into a climactic blow. If the infantry came over fast, Pickett's force could be cut off and annihilated.

Grant agreed with him and promised to help. But to Sheridan the help was a disappointment. He had asked that he be given Horatio Wright's Sixth Army Corps, and he was not able to get it.

The Sixth Corps had been under Sheridan's command in the Shenandoah Valley campaign. By the spring of 1865, it represented the shock troops of the Army of the Potomac. Its men were war-wise veterans who had not yet lost their dash.

They knew Sheridan and Sheridan knew them; better yet, he and General Wright knew one another and knew how to work together. "Give me the Sixth Corps," cried Sheridan, "and we'll finish this business!"

But the Sixth Corps could not be given to him. It was stationed a number of miles to the east, in the trenches facing the Petersburg defenses. To pull it out of line, send in replacements, and move the corps over the almost impassable roads to Sheridan's position around Dinwiddie Courthouse would take two or three days—and Sheridan wanted his infantry by tomorrow morning, before dawn. He would have to take what he could get; and what he could get was General Warren's Fifth Corps, which held the left end of the Federal line and was situated, as March came to its end, just a few miles northeast of Dinwiddie Courthouse.

The Fifth Corps had a famous record. It had been built, originally, around the old division of regulars, Sykes' regulars. It had been commanded by Fitz-John Porter, and it had been McClellan's pet outfit, back in the days when the army was young. By the spring of 1865 its regulars had been whittled down to the vanishing point, but the Corps still kept its regular army flavor. Its drill and discipline tended to be stiffer than in the other corps. It had a strong leavening of regular army officers, and a hold-over of the regular army tradition. By any standard it was a good combat unit.

Its general was famous, too. Warren had had two great days. One was at Gettysburg when, as an officer on Meade's staff, he had spotted the Confederate threat to Little Round Top

and had got troops over in the nick of time to meet the threat. The other was at Mine Run, in the late fall of 1863, when Warren had the moral courage to call off Meade's projected attack on the Confederate entrenchments because he saw what Meade, at a distance, could not know—that the Confederates held an impregnable position and that a Federal attack there would be a bloody failure. It would have been easy enough for Warren to go through with the attack as ordered, with Meade's explicit directive as his protection; instead he cancelled it, on his own responsibility, let Meade's wrath descend on his own head, and saved the army from a disastrous whipping.

He was an interesting sort of soldier, this Warren: slim, swarthy, with a long mustache and high cheek-bones, given to fussing over details, with more of a streak of sensitivity than a professional soldier really needs to have. He had fought Indians in the west, before the Civil War, and after a number of such fights he wrote that the trouble with attacking an Indian village was the fact that in the process one unavoidably shot a good many Indian women and children—and, after the fighting was over, and one came to dress their wounds, one found that they were not howling savages, but, simply, women and children. Again, at Cold Harbor, when the Union Army had climaxed an unbroken month of fighting with a fortnight in the sweltering trenches, under fire day and night, Warren burst out to a staff officer: "For two months it has been nothing but one constant funeral procession past my door, and it is too much! It is too much!"

Warren had a high reputation. Grant remarked that when the Wilderness Campaign began, and he had to consider what he might do if a stray bullet happened to hit General Meade, he had felt that Warren would be the best man to succeed to the command of the Army of the Potomac. He changed his mind later, to be sure, but the fact that he had Warren in mind at the time indicates that Warren was no average officer.

Now when Warren was ordered to take his Fifth Corps over to help Sheridan at Dinwiddie, the assignment looked simple enough—on paper.

Warren's position was no more than half a dozen miles away from Sheridan's. His orders reached him in the evening. Sheridan wanted him to have his men in position at dawn, so that they could strike Pickett's left flank and rear while the cavalry engaged him in front. With any luck at all, it seemed likely that long before noon Pickett's whole force should be destroyed, at only a moderate expenditure in Federal manpower.

Unfortunately, Warren was not going to be making his move on paper. He was going to be moving in Virginia mud, in pitch-darkness, in pouring rain, with 15,000 soldiers who were dead on their feet. The job which looked very simple was, in fact, almost impossible.

Warren's men had been fighting all day—a hard, wearing fight, which had cost many casualties. When night came the troops were in the immediate presence of the enemy, which meant that their withdrawal would have to be handled slowly and with a great deal of care. The orders that came to Warren

from General Meade were extremely confusing and contradictory, and forced him to do a great deal of counter-marching with some of his units. Altogether, it was well past midnight before the movement could actually be begun.

When it did begin there was more trouble. It had been raining for a week, and the whole countryside was a swamp. Squarely across the middle of the road Warren's men had to use there ran a little creek, which the rain had turned into a foaming river too deep to be waded. The column had to halt, in the middle of the night, while engineers tore down a barn or two and built a bridge. Nobody had any sleep, everybody was dead with fatigue, most of the maps were wrong and, what with one thing and another, it was well past daylight when the first of Warren's troops came up to where Sheridan was impatiently waiting.

Sheridan was not carrying his impatience gracefully. The leading element of Warren's column was composed of the brigade led by Joshua Chamberlain, of Maine, and as Chamberlain rode up to report he found Sheridan fuming.

"Why didn't you come before?" barked Sheridan. Without waiting for an answer, he demanded:

"Where's Warren?"

Chamberlain explained that Warren was back at the rear of the column. He tried to add that the line of march was in a bad tangle, but Sheridan interrupted him:

"That's where I expected to find him!"

All in all, it was mid-morning by the time the Fifth Corps came into position at the desired spot. Pickett, meanwhile,

had taken the alarm—being quite as capable as Sheridan, apparently, of seeing that his position was essentially one of great peril. Some echo of Warren's move had reached him, and by sunrise he had pulled his troops back from in front of Dinwiddie Court House and had taken position at Five Forks, in a long line facing south. By the time the Fifth Corps was in position, Pickett was no longer where his flank and rear could be assailed.

So there had to be another move; and before it could be taken the men of the Fifth Corps had to be given a little rest. They had fought all of the day before and they had marched all night long, and for two or three hours there had to be a breather. Then, when the troops had had a little rest, it was necessary to march the Corps five or six miles to the north, to a spot on the open ground near the Gravelly Run Church. The men were sluggish, Sheridan was edgy and impatient, Warren was reserved and perhaps a little sulky under Sheridan's running fire of criticism; the move took a long time, and Sheridan became convinced that Warren was purposely delaying matters.

At any rate, the Corps was finally massed in a spot where it could move straight forward and come in on the extreme left end of Pickett's new line at Five Forks. The cavalry, meanwhile, had pressed ahead and had formed line facing Pickett's shallow trenches. It was late afternoon, by now, and from Sheridan's point of view most of the day had been wasted, but at last the ungainly column of attack got moving. Then there was a final mishap.

*". . . a sweep around Lee's right flank"*

Somehow, Warren had got a defective map. Or perhaps his orders were confused; at this distance it is all but impossible to make out just what went wrong. In any case, when the Fifth Corps finally did move it was half a mile farther east than it was supposed to be. Instead of hitting the end of Pickett's line, it hit nothing at all. Its three divisions simply plowed on ahead into empty country. When Sheridan's dismounted cavalry made their attack they got no immediate help from the infantry.

Actually, this did no very great harm. Warren saw what was wrong, and he went spurring on after his leading divisions, to swing them around and bring them in where they were supposed to be. While he was doing this Sheridan himself came thundering up. In Warren's absence he found the rear division of Warren's command, got it pointed right, and led

it personally into the proper position. The division made its attack, little by little the rest of Warren's infantry got into action, and by sunset a complete victory had been won. Pickett's command was utterly demolished, more than 5,000 Confederate prisoners were taken, Lee's line was turned once and for all—and from that moment the end of the war was just one week away.

At which moment Sheridan sent Warren a curt note relieving him of his command and putting his senior division commander, General Charles Griffin, in his place.

Warren rode up to Sheridan, after getting the note, riding through cheering Union troops which were celebrating the moment of complete victory, and he asked Sheridan if he would not reconsider his harsh order.

Sheridan's reply was entirely characteristic, and was shouted loudly enough for other officers who sat their horses nearby to hear.

"Reconsider hell!" said Sheridan. "I don't reconsider my commands. Obey that order!"

So Warren rode away, disgraced and broken in the moment of victory.

Twenty years later a court of inquiry examined the case, and saw clearly that Sheridan had been cruelly unjust. It was no fault of Warren's that his troops came late to the scene, nor was it his fault that the blow as launched missed its target. In the end the mistakes had cost nothing anyway. The victory was complete and decisive. Nothing had been lost.

But Sheridan was unforgiving. He had not thawed out in

the least during the twenty years that elapsed before the court of inquiry was held. He appeared before the court as a witness, and you can still hear the harsh rasp of his voice in the report of his questioning by Warren's counsel.

"What," Sheridan was asked, "do you claim was Warren's sin of omission or commission in relation to that going off to the right?"

Sheridan answered: "If there was anybody in the wide world who should have made an effort to prevent that, General Warren was the man."

Question. "Undoubtedly. Now do you know whether he made any effort or not?"

"I don't know. I did not realize any."

"Did you ask him what he had done?"

"I could not find him."

"Did you ask him afterward, when you did find him?"

"No sir."

"Did you ask anyone at the time you relieved him?"

"No sir."

"Did you try to get any information of anyone at the time you relieved him?"

"No sir. I had all I wanted."

Studying the battle and reading the record, it is hard to escape the feeling that Sheridan was brutally unjust in his treatment of Warren. But in the light of the history of the Army of the Potomac, it is also hard to escape the conclusion that while this was an act of cruel injustice, it would have been much better for the army as a whole if one or another of its

commanders had committed similar acts of injustice two or three years earlier.

In the whole history of the Army of the Potomac, no general had ever been punished for being just a little late.

When something went wrong, in battle or on the march—and a great many things did go wrong—excuses were always accepted. If what was supposed to happen at five in the morning did not happen until two in the afternoon, nobody got really exercised about it. If today's move took place day after tomorrow, the high command was apt to be very understanding about it—because, in point of fact, the high command itself was as likely as not to be responsible for it.

Go over the list of this army's battles. In most of them you will find someone—like Warren, at Five Forks—coming into action late, or hitting in the wrong place, or not hitting at all when he was supposed to hit—usually with the best reasons in the world, but usually, too, with disastrous effect. You get the impression that the commanders of the Army of the Potomac did not really expect things to go according to plan. Someone was always going to be late, some body of troops was always going to be put in at the wrong time or in the wrong place, somehow the battle plan was going to be upset. It had always been that way, and apparently the commanding general figured that since men are human and prone to error it would always be that way.

And the underlying trouble was simply that this army lacked the one great ingredient for success: grim, ferocious, driving force at the top. Grant had it, to be sure, but things

were set in the mold by the time he got there and the dual command system which he tolerated was too loose-jointed to make quick correction possible. Sheridan, at Five Forks, was applying it. Doing so, he committed a grave injustice. But he also contributed the hard, ruthless, unforgiving insistence on victory which the army had not had before. It is quite possible that the war would have been two years shorter if that note had been present from the beginning.

And this was the reality of the Civil War soldier—a reality just as harsh and unlovely as the reality of any war. The men who survived lived on to a great age in which even their own eyes saw the past through a romantic haze: looking down the years at their own youth they seem to have seen a strange time of gold, in which comradeship and the memory of shared emotion and the magical, deceptive light of lost youth colored the picture. We ourselves do not need to make the same mistake. The old soldiers had earned the right to make it; we have earned nothing, except the privilege of living up, not only to what those old men saw, but to the reality which they forgot.

# The Era
# of Suspicion

ANY study of the nation at war must sooner or later involve a study of the things our democracy does when people are badly frightened.

War itself is a terrifying business; so much so that in the ordinary way of things we are quite unwilling to engage in it. We can face it only when aroused by some emotion so powerful that the terror of war itself is overridden. We have never yet thought our way into a war. Always, we are carried there by our emotions.

The emotions that take us off to war are always highly mixed; being human, we do react to very complicated stimuli, and the motives that lie back of any great step—by an individual, or by the nation as a whole—are usually pretty intricate. We go to war because we desire something very much, because we hope to serve an ideal, because we expect that winning the war will give us a tangible or an intangible profit that will somehow outweigh the terrible cost—and, at least in part, because we are just plain scared of something.

Now a certain amount of fear is a very good thing. There are menaces that we have to be afraid of; Hitler would probably be ruling the world today if he had not scared a good many million people like ourselves into resisting him. But

too much fear is the cause of blind evil and cruelty, and no one has ever been able to determine just how scared a democracy ought to get in time of crisis. When fear becomes too great, democracy is likely to bog down. It inflicts wounds on its own body, and some of the wounds can be a long time in healing.

When the American Civil War began, in the spring of 1861, simple fear probably was not the dominant emotion either North or South. There was, of course, much fear of an abstract, intellectualized sort; in the South, fear that Northern dominance would destroy cherished values—in the North, fear that the secession of the slave states would fatally limit the growth and progress of the nation. But of the kind of terror that is felt with the muscles and the viscera there was very little. That came later, after war had whipped it up. When it did come it proved to be longer-lived than the war that had produced it.

It came quite naturally, because a civil war is bound to breed fear. To the people of the North—and it is the Northern experience that I wish to describe: that of the South is a story by itself—the beginnings of the war brought a highly unpleasant shock. A considerable number of professional soldiers, army officers trained by the nation and sworn to its service, many of them men of substantial fame and distinction, resigned their commissions and went into the service of the Confederacy. It is possible now to understand the tragic conflict of loyalties that tore some of these men, and to see that by going South they acted according to the best light their consciences could give them, but it was not easy for people in

the North to understand that in 1861. All that they could see was that a number of the very people who were supposed to be the country's defenders had suddenly turned out to be no defenders at all but were enemies.

That was only the beginning. Washington, the national capital, was full of subversive elements. It is probable that a majority of its people at the start of the war hoped that the South would win. Many of them worked for the government; some of them, up to the moment hostilities began, had sat in Congress, and for all anyone knew some might still be sitting there. The city abounded with spies and with Confederate agents of high and low degree. No one had ever heard of the expression at that time, but a potential fifth column of great strength existed in the very shadow of the Capitol dome.

What was true of Washington was true, often to a lesser extent, of many other cities. When the first Northern troops marched through Baltimore, on their way to garrison the capital, they were attacked by a street mob. Federal soldiers in far-off St. Louis got into a bloody street fight with another mob. In the border states there was no way to tell who might turn out to be an enemy; even much farther north there were plenty of people who had strong, intimate ties with the South.

In all of this there was abundant reason for fear. When the fighting began, and the cost of the war began to be painfully visible in the shape of red casualty lists, the fear increased. The enemy in the field, it developed, was not going to be whipped easily or at once; it became quite intolerable to feel that he might be supported by enemies at home. The feeling

was intensified as ardent patriots—newspaper editors, political leaders, all who felt responsible for keeping war-time emotions at a high pitch—preached about the dangers of treason and of the infinite damage that could be done by traitors.

Out of this fear came suspicion—cold, creeping suspicion of anyone and everyone who did, or seemed to be doing, anything that might give aid and comfort to the Confederacy. Again, it was perfectly natural for this suspicion to exist; after all, trusted men *had* turned into enemies without warning, there *were* Southern agents in the North, attempts to bring about Northern defeat *were* being made, in Washington and out in the country as well. Northern patriots needed to be a bit suspicious; the opening stages of a violent civil war are not a time in which people can or should think that everything will work out for the best.

But fear and suspicion can be self-accelerating and, for a long time, self-perpetuating. When they rise to a certain height they make it impossible for democracy to operate properly. We in our own day should understand this; we too have seen what can come when people—with the best of reason—become unduly fearful and suspicious.

Some of the manifestations of universal suspicion were simply funny. It is recorded that an infantry regiment from one of the Northern states was proceeding to Washington by train and found its progress delayed. The train would stop for no good reason (except, possibly, that the signals were set against it) and when it went on again it would go slowly. It seemed clear to the soldiers that this sluggish progress could

be occurring only because the engineer was a traitor and wanted to aid the Confederacy. So a squad, led by an officer, went to the cab, levelled muskets at the hapless engineer's head, and announced that they would ride in the cab with him the rest of the way and see that a proper speed was maintained. He would retard the advance of that troop train only at the cost of his life. Fortunately, the track seems to have been clear the rest of the way in: the engineer was not shot, the train was not wrecked, and the troops did get to Washington.

A little later there began to be developments that were not in the least funny. One of these—wholly typical of the way unbridled suspicion works, and speaking in a language we today are well qualified to understand—involved a Union brigadier general named Charles P. Stone.

Stone was a regular army man, one who would have seemed to be above suspicion. In the first months of 1861, when Washington was preparing for Abraham Lincoln's inauguration amid rumors that a Secessionist putsch would make it impossible for him to take office, local troops were hastily recruited and the command of them was given to Stone, who took extreme precautions to make sure that the law was upheld. Lincoln trusted him, the War Department trusted him, and by mid-summer he had been given command of a brigade of New England and New York regiments camped along the Potomac twenty miles above Washington. There were Confederates on the far side of the river, and there was a good deal of somewhat pointless skirmishing between the two armies, but for the time being this sector was relatively quiet.

Stone began to have difficulties, simply because he did his best to carry out the orders that had been given him.

At that time the government had officially declared, through a statement by the President and passage of a resolution by Congress, that the only purpose of the war was to restore the Union. The question of slavery was not involved. Runaway slaves who sought refuge in army camps were to be returned to their owners. United States troops were not in the field to interfere in any way with the peculiar institution. This was official government policy, and General Stone faithfully followed it.

His difficulties arose because most of the men serving under him came from areas of strong abolitionist sentiment. Early in the fall, two fugitive slaves from a nearby Maryland farm got into the camp and were concealed by the men of the 20th Massachusetts regiment: the same regiment, incidentally, in which young Oliver Wendell Holmes, later to be a distinguished justice of the United States Supreme Court, was serving as captain. The owner of the slaves came to camp to reclaim his property. Stone had a young officer take a squad of armed men, comb out the camp of the 20th Massachusetts, seize the slaves, and return them to their owner. In this he was actuated by no sympathy for slavery or slave-owners; he was simply doing what his plain orders told him to do.

But the Massachusetts soldiers were disturbed. They wrote to their governor, a forthright abolition-minded character named John A. Andrew, who immediately got off a letter to the regiment's colonel officially reprimanding him. The

colonel—a West Pointer named William R. Lee, who at the military academy had been classmate of a young southerner named Jefferson Davis—passed the letter along to General Stone, who wrote to Governor Andrew telling him in effect to keep his hands off of General Stone's troops. The distinguished Senator from Massachusetts, abolitionist Charles Sumner, then took a hand in the game and denounced General Stone in a speech in the Senate. Thus with the war hardly begun, this general had already got into trouble with two highly determined men of much influence with the Federal administration.

All of this might well have passed off, except for a military disaster that happened shortly thereafter to men from General Stone's command.

On the Virginia side of the Potomac there was a Confederate army camp, and toward the end of October a captured Confederate teamster brought in word that these soldiers were about to make a move of some sort. General George B. McClellan, commander of the Union army, called on General Stone to make a movement known as a reconnaissance in force; that is, Stone was to send troops across the river, skirmish with the Confederates, and find out what strength they had and in general what they were up to.

So Stone sent several regiments over the river, and these regiments, early one morning, found themselves in a weedy clearing surrounded by woods on the Virginia side of the river, on top of a high bank known locally as Ball's Bluff. The Confederates were waiting for them, attacked them before

*"... a high bank known locally as Ball's Bluff"*

they were ready to advance, killed the colonel who was in command of the movement, and completely routed them. Many of the Federals were killed or wounded, and many more were captured; the few survivors somehow made their way back across the Potomac, and the whole move had ended in unrelieved catastrophe.

This fiasco led to much more trouble. For one thing, the whole move had obviously been handled with a minimum of skill—due not so much to any error by General Stone as to the lack of military knowledge displayed by the untrained officers who were in immediate charge of it. For another

thing, the commanding colonel who had been killed was an important ex-Senator, one Edward D. Baker, an intimate friend of Abraham Lincoln and a power in the Republican party—a man who had resigned his seat in the Senate in order to join the army, and lost his life in this first experience of combat. Additional attention was drawn to the matter because Massachusetts' Colonel Lee was captured and lodged in prison in Richmond; and at that time the United States government, which had recently taken a Confederate privateer, was saying that it was going to hang the privateer's officers as pirates (a position from which, before long, it would quietly recede). As a reprisal, the Confederate government announced that if these hangings took place it would hang Union army officers in its possession, and the first man nominated for a place on the gallows was this same Colonel Lee.

The Ball's Bluff business, as a result, became a most celebrated case, and Congress immediately looked into it. To do so it set up a ferocious, ardently patriotic, solidly anti-slavery group known as the Joint Committee on the Conduct of the War, with Senator Ben Wade of Ohio as chairman, and this committee promptly began to hold hearings.

General Stone was one of the first witnesses called. He explained the circumstances under which the move to Ball's Bluff had been made, was questioned in no great detail, and left the hearing feeling that that was that. Actually, he was at that moment on the road to complete ruin, although he did not realize it until a bit later. For the Committee heard other evidence, and as it did so its deep suspicions began to

harden. A train of obscure witnesses testified that there had been funny goings-on in General Stone's brigade. The man had been too eager to capture and deliver to their owners escaped slaves; he had argued bitterly with stout patriots like Governor Andrew and Senator Sumner; mysterious flags of truce had gone back and forth between Union and Confederate camps, in the days before the battle, and there were wild stories of strange signal lights and secretive messengers exchanging information across the river—and in the end, the Joint Committee came to the conclusion that General Stone was a disloyal man, that he had been in secret communication with the Confederates, and that he had purposely designed this movement so as to give the Confederates a chance to win a victory.

The Committee never formally stated this belief. It simply communicated all of its suspicions, very quietly, to the War Department where, in Secretary of War Edwin M. Stanton, it found an official quite as suspicious as its own membership. The War Department considered the matter and, a few days thereafter, General Stone was deprived of his command and locked up in prison.

Bear in mind that the general was not formally accused of anything at all. There were no charges against him; when he tried—as he did try, desperately—to clear his name, he ran into the baffling fact that there was nothing to clear it from, since no one had accused him of anything. He was simply locked up in prison, the country knew him as a disloyal general who had been caught in a treasonous act, and his whole

career was wrecked. He stayed in prison for six months or more. He could not answer his accusers because he could never find out quite what he was accused of; he could not be brought to trial because nobody else could find out either. He was just encased in a cloud of suspicion, all the more damaging because it was completely unformulated.

Long afterward he was released—not exactly cleared, but at least released—and in the latter part of the war he was given a job as staff officer for a general commanding troops in occupied Louisiana. But he never recovered from the blow dealt him by the Joint Committee. A professional soldier on the threshold of what looked like a promising career was finished.

And the importance of all of this is that it makes a perfect case history of the sort of thing that can happen in this country when fear and suspicion have really taken root, as they had taken root in the fall of 1861. Due process of law, to say nothing of elementary decency and fairness, can go straight out the window. To be suspected can become just as bad as to be convicted of something; and the suspicion can arise through no fault of one's own, but simply through bad luck or political ineptitude.

Now of course what the Joint Congressional Committee did in General Stone's case was high-handed and deplorable; but it is necessary to remember that the committee was not working in a vacuum. People *were* afraid—in Congress, and out of Congress. Being afraid, they were also suspicious, and the most monstrous suspicions seemed justified. The mere fact that they had good reason to be afraid, and that men who

a few months earlier had seemed to be above suspicion had in fact turned out to be national enemies, must not be forgotten. Also, the actions of this Committee made fear and suspicion all the more prevalent. If a Congressional committee, inquiring into subversive activities, could require a brigadier general to be thrown into prison, then the national safety must indeed be under grave threats. Each act of this kind would serve to increase the very tension which led to the act in the first place.

Furthermore, it may not be out of place to point out that political ends were to be gained by the men who were conducting the investigations. Congress was dominated by the radical Republicans—men, that is, who were determined to see Union armies led only by men whose political views coincided with their own. By ventilating far-fetched stories of plots and treason they could insure their own control over the operations of the Federal government. To create fear and suspicion was not only natural, perhaps even justified by external conditions: it *paid*.

The same sort of thing happened over and over again during the Civil War, although not all of the persons suspected landed in prison. But from the beginning to the end, general officers in the Federal service had to labor under the intolerable knowledge that they might be suspected of treason for reasons over which they had no control—a knowledge made all the more bitter by the added realization that a career could be ruined even though the man suspected had never even dreamed of committing a disloyal act.

In Kentucky, Brigadier General Charles F. Smith, former commandant of cadets at West Point, a soldier in whom such men as Grant and Sherman had complete confidence, almost went the way of General Stone, and for the same reason. He, too, had obeyed orders relative to fugitive slaves, and had trodden on the toes of Northern governors whose ideas differed from his. He was slated for removal, at one time, and although he was luckier than General Stone—the charges against him were finally dropped, and he kept his command —he was understandably bitter about it. To a friend he wrote that he would faithfully serve out the war to the best of his ability, but that when the war ended he would resign from the service of a government "where to be suspected, merely, is the same as to be convicted."

Even General McClellan himself had similar troubles. He too was suspected of disloyalty, and when he fought the famous Peninsula campaign in 1862 the Secretary of War and half of Lincoln's cabinet actually believed that he wanted to lose. Lincoln stuck by him and saved him; but after the battle of Antietam, McClellan's slowness in moving against General Lee revived the old suspicions, and in November of 1862 he was removed from his command and sent home to sit out the rest of the war in New Jersey.

This sort of thing, to repeat, was more or less inevitable in a civil war. Odd things did happen, in the American Civil War, and if fear and suspicion abounded there was, after all, a good deal of reason for it. And the injustices that were inflicted on innocent people along the way might be washed

off as simply incidental to the fighting of a civil war, except that the habit of suspicion which was acquired during the war did not end when the war ended. Instead it went on, to exert a profound effect on the nation's subsequent history.

In the spring of 1865 the Civil War came to an end. Lee surrendered, Johnston surrendered, the whole South was occupied, and the Confederacy vanished in smoke and mist, to be restored no more. North and South alike, people were tired of the war and tired of the hatreds and terrors born of war. As far as anyone can judge there was a real desire, all across the land, to reunite the nation on a harmonious basis and to carry out Lincoln's dream of an enduring peace made with malice toward none and with charity for all.

Then Abraham Lincoln was murdered, at Ford's Theater, and the whole era of suspicion was suddenly reborn.

It was reborn in large part because Secretary Stanton and other important government officials actively presided at its rebirth. They did all they could do—and they were in a position to do a great deal—to make Americans suspect the good faith and the decency of those who now, by the verdict of war, were to be their fellow-citizens again.

There never seems to be any true simplicity in human affairs, and the situation surrounding Lincoln's assassination was extraordinarily complex. To an extent, Stanton and the others had some reason for being fearful and suspicious. In the late months of the war the Confederate government had done its utmost to stir up subversive activities in the North. They controlled these activities from Montreal, safely across

the Canadian border, and they tried to do various things: to capture a Federal naval vessel on the Great Lakes, to seize Northern prison camps and free Confederate prisoners, to burn New York City, to start a rebellion of sorts in Chicago at the meeting of the Democratic National Convention in the fall of 1864. None of their movements actually came to anything in particular, but they had been trying hard enough and the United States War Department, which had a pretty fair espionage system in operation by this time, knew a good deal about their activities. It was particularly well posted on the work which the leaders at Montreal were doing.

John Wilkes Booth, who killed Lincoln, was of course an ardent Southern sympathizer. His movements in the months before the assassination are still obscure, but he had visited Montreal, and Secretary Stanton knew about it. When Booth was identified as the man who had killed Lincoln, it was not entirely illogical for Stanton to conclude that this was part of the great Confederate plot.

We know now that it was nothing of the kind. Booth was a madman who acted on his own, and neither Jefferson Davis nor anyone in his government had any connection with his insane act of revenge. But at the very moment when the people of the North were stunned and angered by the murder of their President, their government—through Secretary Stanton—formally announced that this murder had been ordered from Richmond and that it was simply the logical culmination of the devious game which Southern traitors had been playing for four bitter years.

The result was sheer tragedy. Almost overnight, the dawning spirit of magnanimity which had been developing in the North evaporated. Fear and suspicion came back into being with redoubled strength. And the chance that a fair, workable peace between the sections might quickly be made evaporated. Instead, the whole of the reconstruction era was clouded by the feeling that these Southerners just were not to be trusted. They were men to be feared, men to be watched, men to be controlled by force—and a bitterness and estrangement flared up that took generations to die down. Harmony between the former enemies was not restored promptly; it had to develop, by a long, slow process, over the succeeding decades. Nor was justice done to the Negro. In the highly emotional atmosphere of the reconstruction period he was forced off into a Jim Crow corner, and the task of working out his destiny was left for our own generation to grapple with.

It would hardly be worth our while, at this late date, to spend so much time examining the ugly emotions that prevailed in the Civil War if it were not for the fact that the lesson for our own day is of direct and immediate application.

It does happen, now and again in this country, that we are swept by a wave of panic suspicion; a time in which we are ready to distrust the motives and the actions of our fellow-citizens and suspect any man of the worst simply because someone points a finger at him. The tragedy of such a panic is that it creates an atmosphere in which democracy just does not work. Democracy proceeds on the assumption that we do trust our fellows. Our whole tradition of freedom—the oldest

and the noblest tradition we have—rests on the belief that we and our fellows are worthy of freedom. A time of universal suspicion is a time when we deny that belief; a time, in other words, when we deny the faith that gives our lives meaning.

We are today emerging from the latest of these spasms of terror. We ourselves have known a time in which the mere fact that a man was accused of something was taken as proof of his guilt. We have been reminded of Mark Twain's comment on the reign of terror under the Doges of Venice, when a committee on public safety received anonymous accusations against the loyalty of citizens. As Mark Twain remarked, if the committee could find no proof to support an accusation it usually found the accused guilty anyhow, on the ground that the lack of proof simply showed how deep and devious the man's villainy really was. We have lived through an era in which it was widely taken as a crime for an accused person to invoke the Bill of Rights in his own defense—as if the provisions of the Bill of Rights were not meant to operate precisely at a time like the present. We have seen a time in which no one in authority seemed willing to place the least bit of trust in the innate loyalty, good faith, and intelligence of the American people—times which led former Senator Harry Cain to burst out with the cry: "A whole clique of spies could hardly do as much damage to us as could our failure as a government to have confidence in the people."

It is the American tradition itself that is in danger in such times. The men who whip up our emotions, strive to make us afraid of the dangers that surround us—which, Heaven

knows, are real enough now and then—and attempt to arouse our suspicions of anyone and everyone on the basis of that fear, are tampering with something basic, something of such profound importance that it is beyond their own understanding.

For this American tradition revolves entirely about freedom, and the freedom that we serve is unabridged and unadulterated. It applies to everybody in the land at all times and places—to those with whom we disagree as well as to those with whom we do agree. And the secret of it is—just courage; the kind of courage, welling up instinctively in the breasts of individual citizens, which refuses to be panicked, which becomes strongest precisely when the danger is greatest; the kind of courage which led Byron to write:

> Yet, freedom, yet, thy banner, torn but flying
> Streams like the thunder cloud *against* the wind!

When we give way to fear, in other words, that banner ceases to go streaming against the wind. It becomes the wind's prey, and flutters helplessly in the gale. We deny something that we must not deny when we give way to suspicion. The moments when democracy is in greatest peril are precisely the moments when we most need to place our trust in it; and democracy was not built upon the assumption that we have to keep a close watch on the loyalty and fidelity of our neighbors.

It was built, instead, on simple faith—faith in ourselves and

faith in our fellows, faith that the thing we believe in is immortal and comes from an unfailing and everlasting source. So long as that faith is unshaken we can go forward with confidence—or, to say it the other way around, so long as we do go forward with confidence our faith will remain secure. The men who try to undermine it and replace it with fear, with suspicion and with hatred are attacking the one thing without which we cannot live.

# The General
# as President

THE presidency of Ulysses S. Grant makes one of the haunt-ing stories of American history. It is a tragic story—tragic both for Grant and for the country—for it shows a great man and a great nation confronting a profound and complex set of problems whose solution demanded qualities which neither the man nor the nation quite possessed. The endowment that can win a great war is not necessarily the endowment that can win the succeeding peace, yet it is entirely natural for people to think that it is; and what happened to Grant after Appo-mattox is the classic example of the fruits of that kind of thinking.

Probably it was inevitable that Grant should be sent to the White House in the first presidential election following the Civil War. In the spring of 1865 and for some time thereafter he was probably the best-liked, most completely trusted man in the United States. Once Lincoln was gone he seemed to stand for everything Lincoln had stood for; he had the hard ability that could win the war, and he had also the broad magnanimity and understanding that could erect a just and lasting peace. The country was prepared to reward him, if he wanted reward; it was also prepared to turn all of its problems over to him on the theory that he—perhaps he alone—had the

selfless, dedicated strength to carry them until they were solved.

In his strengths and in his weaknesses, Grant perfectly represented the nation that elected him. Consider, for instance, their attitude toward the military arts and war itself.

Grant never cared much for soldiering—and neither does America. In ordinary times we feel ill at ease about military matters. We have contributed comparatively little to pure military theory, because we very rarely put our best brains to work thinking about it. In the development of weapons, of course, we do very well. Weapons are gadgets, pure and simple, and with gadgets we have always been very ingenious. But war is a different question, involving not so much the gadgets themselves as the theory on which they are to be put to use, and on the theory we tend to be weak. In time of peace it bores us. Never yet have we gone to war properly prepared for it.

Yet when war does come the nation always seems to find itself—precisely as Grant found himself in 1861. He had been a failure in the pre-war peace-time army, and he had done no better as a civilian. The challenge of war was a challenge he could meet superbly well, and from the moment he became a brigadier general, in the summer of the war's first year, he demonstrated his capacity to lead armies and to win battles. And what was true of him had been true of the country as a whole; was true then, and has been true in all subsequent wars.

America, surprisingly enough, shows an amazing competence in the practice of those military arts which, in peacetime, it seems to despise. We begin by fumbling and stum-

*"... Grant perfectly represented the nation that elected him"*

bling, and then eventually we discover that making war is chiefly a matter of calling up all the energy, force, and resources which we possess and applying them without regard to cost or consequences to a single end—the defeat of the enemy on the field of battle. Usually we do very well at this.

This is understandable, for war simply calls on us to do with all our might what we do best anyway—that is to act. It relieves us (or it seems to relieve us, which comes to the same thing) of the need to do any serious thinking. All of the

imponderables are suddenly removed. We have always had more energy and strength and resources than we have known what to do with; the baffling problem about our industrial depressions always seems to be the fact that we have muscle that is not being put to use. War provides a new goal. It demands that we use our muscle to the utmost; in other words, it challenges us to take our greatest single talent and exercise it to the limit.

So while we are not a military nation, we do turn out to be pretty war-like when the time comes. The challenge of war is one challenge we know how to answer.

It must be repeated that it was also this way with Grant, for the story of his presidency is, in its deepest sense, the story of the nation which chose him as its leader. Choosing him in 1868, the nation simply confided in its own native genius. In this man who represented the great average so perfectly, it found one who, like the country itself, had been able to function at complete capacity in the turmoil of war. Grant had led the Northern armies to a complete, overwhelming triumph, and the country (as Northern folk innocently supposed) had won an enormous victory.

And then, having won it, the country did not know what to do with it. Nor was Grant the man to provide the answer.

Again, this is not simply the story of Grant and the 1860's. It is a theme which recurs over and over in American history. We go to war and we make victory an end in itself. "Unconditional surrender"—a phrase of Grant's own, by the way—says all that we want to say about our war aims. We will beat

the enemy once and for all, and somewhere in the back of our minds there seems to lurk the idea that if we can just do that all of the complex problems which brought on the war will vanish and will bother us no more. We always suppose that once the victory is won we are going to go back to a lost golden age. We lost an ideal condition when war began; we shall regain it, once the guns have cooled and the flags have been furled.

The trouble is that it never works out that way. War creates more problems than it solves, and when war ends all of these problems press for attention at once. The political leaders who have the country's affairs in their keeping are usually blamed for this, because they have to call for readjustments which are not in the least like the contemplated ideal. It becomes very easy to feel that the politicians ought to be thrown out and that the way of the soldier is the way to follow—the way of the good soldier, who cuts his way through to the final goal regardless of obstacles and without compelling anyone to do very much thinking about the goal itself.

And if, at the end of a great war, the soldier who seems to have been chiefly responsible for the victory turns out to be a modest, likable, and unassuming man, given neither to colorful phrases nor to deep personal ambitions, we are very likely to turn to him. Bear in mind that the personality of the soldier is all-important, here. We have an ingrained distrust for the flamboyant man who can strike noble postures. We do not, in the last analysis, make presidents out of our McClellans, or out of our MacArthurs. We turn instead to the Grants or the

Eisenhowers, the men who are like our own selves greatly magnified, the men with whom we can feel a drowsy and unquestioning confidence.

So it happened that in 1868, in the first presidential election following the Civil War, Ulysses S. Grant was sent to the White House.

This was unfortunate because what people really wanted then was a man who could pass miracles. The war had been won but somehow the long-lost golden age obstinately refused to return. Pre-war conditions did not recreate themselves overnight, nor was any magic of man able to restore them, because the act of war itself had killed them forever. Specifically, in 1868, men could see that the Union had been restored but that an enormous amount of very hard work had to be done before it could again be the mystic thing so many men had died for. In the same way, slavery had been abolished, and a running sore in the body politic had been removed—and yet the Negro free seemed to present as many problems as the Negro enslaved.

What had happened, obviously—it is easy to see it now, although it was hard for men to see it at the time—was that the war had been a beginning and not an end. As we saw in an earlier chapter, it was a point of departure: henceforward the country would go *on* from the place where the war had left it. By no conceivable legerdemain could it go back to the halcyon days of the past. It was facing the future, and the future was veiled in mist and made ominous by the blowing of powerful winds.

And to face this future, the country chose the quiet little man who had won the war, the man who in his own character seemed to express magnanimity, the man who had never hated his enemies and had always stayed aloof from political struggles—clearly, a man who must understand peace as well as he understood war.

The result was tragic, because what was needed after the Civil War—after any great war—was a man who could transcend the national character. Instead of transcending it, Grant embodied it. His genius had been that he could compel men to be themselves. He could not make them surpass themselves and that was what this time called for.

Consider the odd quirks that fate sometimes follows. A man can make a minor decision of no importance whatever—and it can influence the rest of his life and the destiny of a great nation. On April 14, 1865, Grant was called on to make such a decision. He was invited to attend Ford's Theater, with President and Mrs. Lincoln and with Mrs. Grant, and he wanted to get up to New Jersey and see his children. Washington bored him, being on public display irked him, and it was really of no consequence to anyone whether he joined the theater party or not. Grant decided not to go. Instead, by the time the curtain went up, Grant was on a train bound north, and the Lincolns went to the theater without him.

You know what happened. John Wilkes Booth was of the party that night, and he fired the most fatal, tragic bullet ever fired in American history—the bullet that killed Abraham Lincoln. If Grant had been present, Grant would almost

certainly have been shot. Dying then, he would have had a swift and permanent apotheosis, precisely like the one that came to Lincoln. He would have become a martyr, above and beyond criticism, a national hero to whom death had come in the moment of triumph; and he would have been spared the eight cruel years in the White House, in a job which he was never quite able to comprehend.

Grant made his choice. He did not go to the theater that night, and three years later he went to the White House. And there he was called upon to demonstrate that the qualities that had made him great as a soldier were exactly the qualities that would be of little service to him as president.

Admittedly, he was put into office at a time that would try the most skillful of politicians. Unfortunately, it would take a politician's talents to meet those times, and Grant's great virtue—in the eyes of the electorate—was the fact that he was not a politician at all. He was as little a politician, probably, as any American who ever lived. From start to finish, he was the pragmatic American realist—and the successful politician, of high or of low degree, had his base as a mystic, because he has to work all of the time with intangibles.

But in 1868, as is true after all our wars, the people were tired of politics and disillusioned with politicians. Politics had led up to the war; for more than a decade people had lived under an almost unendurable political strain, and they wanted no more of it. Andrew Johnson, who succeeded Abraham Lincoln, had been enmeshed in politics from the moment he took office. With an almost fantastic lack of skill, he had tried

as best he could to carry out the conciliatory policies, as respecting the Southern states, which Lincoln had bequeathed to him. He had run into bitter political opposition, conciliation had gone by the boards, the chance for an enduring peace made with justice and charity for all and with malice toward none had evaporated in the dreadful heat of the sordid impeachment trial, and what America had won in the war seemed to be disappearing in war's political aftermath. Americans then wanted to get away from the talkers and the schemers and turn to a decent, straightforward man who would clean things up and carry the burdens which were a little too heavy for anyone else to carry.

Except that it didn't work out quite that way. The fine times that were supposed to return with peace would not come automatically. The country had been shaken to its foundations by the war, and everything had been changed. Social stratification had been broken up, new tides of transportation and finance had come into being, and the immense stimulus of war had created an industrial boom which was like nothing anyone had ever dreamed of before. Furthermore, the men who had to adjust themselves to those changes, and who had grown tired of fear and hatred, were being plagued by the fears and hatreds born of war. In all American history no more delicate job of political leadership had been called for than was needed now. The country had to be rebuilt, the proper road ahead had to be found and followed in spite of the fierce, illogical emotions left by the war—and all of this demanded political skill of the very highest order.

But the country was tired of politics, and Grant was no politician. Indeed, he did not even understand the nature of the job which was his once he entered the White House. In the depth of his political innocence, he supposed that the president should be a passive character; he announced that he had no policy to enforce against the will of the people, and he repeatedly demonstrated that he believed this will was to be expressed in Congress. When he accepted the presidential nomination he said frankly that he could not outline a policy for the years just ahead because new issues would arise and the public mind would change. "A purely administrative officer," he said, "should always be left free to execute the will of the people."

Undoubtedly a great many Americans agreed with this. Yet it embodied a tragic misconception of the responsibilities of the nation's highest office. Grant believed that he was supposed to be a purely administrative officer, yet such a person, in the White House during the challenging years of reconstruction, could no more meet the problems those years would bring than he could sprout wings. The leadership that the times demanded could not, in the very nature of things, come from Congress. It had to come from the White House, and Grant quite honestly believed that the president was not supposed to be the leader.

The underlying problem seems to have been simply this: the training received by a professional soldier (which was all the training Grant had had) is of all trainings the one worst devised to fit a man for political leadership.

Deeply ingrained in the American subconscious there seems to be a lurking fear that the professional military man, if put into high office, will gather to himself too much power. The road to dictatorship is thought to begin that way; the soldier is used to giving orders and to having them obeyed without question, and if he becomes president, some ancient instinct seems to tell us, he is apt to try to do too much. Certainly this sort of thing has happened in other countries— from the Rio Grande all the way to Patagonia, not to mention Europe.

But this instinct is mistaken, as far as this country is concerned. The trouble with putting a professional soldier like Grant in the White House is not that he will try to exercise too much power but that he will try to exercise too little.

Consider the indoctrination of the West Pointer. From the moment he enters the Military Academy to the day when he finally leaves the army and goes into retirement, he is taught to look first and last to Congress. It is Congress that passes supply and money bills, controlling the basic details of the soldier's life. It is Congress that declares war, Congress that upholds or rejects the treaties that end war, Congress that confirms or nullifies the promotions of officers, Congress that enacts the laws which govern every step of the soldier's career. Presidents and Secretaries of War come and go, but Congress is always there. No one is made as conscious of this fact, every day of his life, as the professional soldier. Indeed, the more faithful the soldier is to the concept of democracy, the more clearly he sees himself as an instrument chosen to carry

out the country's will—and these two phrases describe Grant perfectly—the more certain he is to feel that the final controls lie ultimately in Congress.

That is where the controls belong, to be sure. But the one man in the United States who has to understand that something more is needed—the one man who has to see the unending need for guidance and leadership in the executive branch—is the President of the United States. He *must* lead, not by weight of authority but by the politician's sure understanding of the desires and motivations of his fellow-citizens and of the multifarious ways in which the machinery of government can best be made to operate. And this was the one fact that all of his training and experience made it impossible for Grant to see.

Grant considered himself above and beyond politics. His very selection of his cabinet showed this. Instead of making his choices as Lincoln had made his, after long consultation with party leaders and with a canny eye to the way in which different elements in the electorate could be bound to support of the administration, Grant chose his cabinet just as he might have chosen a personal staff while commanding an army. He consulted literally no one, and the slate as he finally presented it surprised no one more than it surprised the Republican leadership.

As an example of the political naïveté which governed Grant in his cabinet selections there is the case of A. T. Stewart, whom Grant named as his Secretary of the Treasury. Stewart was an exceedingly wealthy New York merchant,

and Grant seems to have picked him on the theory that so rich a businessman would save money for the country in the handling of its finances. But it developed, when Stewart's name came before the Senate, that there was a law saying that no one financially interested in trade or commerce could run the Treasury Department. Grant asked the Senate to exempt Stewart from this law and the Senate refused. Stewart offered to turn his business over to trustees, with the profits going to charity, and the Senate still refused. In the end Grant had to withdraw Stewart's name and nominate someone else.

The case was typical. The way in which the cabinet was put together was clear notification to party leaders in Congress that Grant was a babe in the political woods. As a result, the controls slipped out of his hands and he was never quite able to regain them. (The first six months of a president's administration are crucial; if the base for subsequent political leadership is not laid then, the chances are that it never will be laid.) The essence of power passed from the White House to the Capitol and it did not come back.

Under Grant, the White House took on the atmosphere of an army camp. Grant brought over into his official family the officers who had served on his staff in the army, and did his best to follow the familiar military "chain of command" setup. He knew how a commanding general ought to act, as well as any American has ever known, but that knowledge was of scant use to him as president. The presidency does not work that way.

It must be added that the problems facing Grant were nu-

merous and complex. It was up to Grant to make a transition from war to peace, restoring the currency, balancing the budget, and unleashing the energies of the country's expanding productive system. It was also necessary to make the reunion of North and South (bought at such frightful cost) something real and lasting, and to provide justice for the newly-emancipated Negro. In many respects, it must be said, a fairly good job was done. Inflation was checked, the national credit was restored, a solid currency was created, industrial development was indeed fostered—with unconscionable profits for insiders, and with substantial wreckage along the way—and the difficult foreign affairs problems raised by the war were, in one way or another, satisfactorily solved.

The Union itself was put back together again, after a fashion, and although a great deal has been written about the horrors of the reconstruction period it ought to be remarked that it could actually have been a good deal worse. A wholly victorious government settled an extremely bloody and desperate four-year revolt and did not, afterward, resort to hanging and proscription lists. It tacitly admitted, finally, that there had been no treason and no traitors, and in the long run the conquered-province theory was quietly dropped. Blood was shed during the reconstruction period, to be sure, but most of it was shed by colored men who stood with the victors rather than with the vanquished. The record of the Grant administration does have something to be said for it. American Presidents have faced smaller problems and done worse with them.

But in the main the eight years of Grant's presidency are a record of missed opportunities. There is no need to go over the sorry tale of political graft and corruption—crookedness, it should be added, which never touched Grant personally, but which certainly did touch some of his closest associates, not to mention a number of the very men in Congress who were reaching out to seize the leadership Grant himself was unable to seize. America in the 1870's was entering on an enormous money-making splurge and many old standards were forgotten. No President could well have prevented it; it can only be said that a President with more political awareness might have kept his own administration from appearing to be responsible for so much of it.

Most tragic, however, was the failure to grasp the extraordinarily difficult race problem. Slavery had ended and the Negro was free, now, but the freed man seemed to present as many problems as the slave and nobody knew quite how to grapple with them. Perhaps it was simply impossible for the war-weary, bewildered people of the 1870's to solve these problems; the tragedy is not so much that the race problem went unsolved as that there was, at last, mutual agreement not even to try to solve it. It was left for future generations; among others, for ourselves.

By instinct, Grant was a moderate, and a very human man to boot. He deeply wanted to see the Union cemented together again, and he did not want to see the colored man thrown to the wolves in the process. But his inability to use the political machinery at his command—his complete failure to exert

political leadership—threw him, at last, in the hands of the extremists, the Republican radicals, the vengeful men who used the Negro as a pawn and wound up by leaving the Negro in a very bad fix indeed. They, finally, were the only people Grant could work with. Under them, the reconstruction program got stiffer and stiffer—until, finally, it broke. The real tragedy of the Grant administration lies in what might have been and was not.

"Where there is no vision," wrote the Psalmist, "the people perish." The vision—that glimpse of the heights a people can rise to, the heights that are within the reach of the aspiring human race, the lofty summit some foreknowledge of which is buried in each man's heart—that much Grant understood and shared in. But the vision by itself is never enough. Along with it there must come the ability to make other people see it and the hard practical knowledge of the way in which the people can be helped to turn it into reality. There Grant fell short. His tragedy was his country's. The President does, finally, in a strange way, reflect the wishes of the people who elect him. The wishes of the people who elected Grant were to let someone else do the worrying and carry the load, and in America it can't be done that way. In the long run, the President and the People advance together.

# The Heritage
# of Victory

AMERICA, in 1860, was a democracy. And while in many
ways it was a very good democracy, it was strictly limited. It
rested on the assumption that there were superior people and
inferior people: white people, that is to say, and black people.
Democracy was for the white people. For the black people
there was either outright exploitation or, at best, a limited and
not really very friendly sort of tolerance. Except for a com-
paratively few dedicated abolitionists, nobody wanted to dis-
turb that situation. It worked—at least, it worked from the
white man's point of view, and it was a white man's democ-
racy—and hardly anybody was prepared to come to grips with
the race problem that lay beneath it.

As long as slavery existed, that problem did not have to be
faced. In fact, under slavery it did not really exist. If one race
is owned by the other race, there is not any question about the
way in which the two races are going to get along together:
no question, at any rate, that cannot be settled by rigorous ap-
plication of the police power which rests in the hands of the
race that is dominant. The institution of slavery lasted as long
as it did because, when you get right down to it, it offered
a handy way to sweep an insoluble problem under the rug.

And that was the thing that bothered everybody, back in

*". . . the guns have cooled . . . the flags furled"*

the days when slavery's existence was such a burning issue: end slavery and there is no way on earth to avoid a grapple with the race problem itself. Once slavery disappeared, the people of the United States were compelled to think and to act upon the question of the black race, the white race, and the manner in which they are to get on with one another in a land where they are bound to keep on living together—a land, furthermore, whose people deeply prize the ideal of human democracy.

The Civil War, finally brought to a conclusion, took us up to that point and then dropped us, leaving us to work out our own salvation. And we have not done too well at the job since.

We did try, in a way, to be sure. The men of the North who had abolished slavery without exactly intending to do any-

thing of the kind did make an effort, after 1865, to look their problem in the face. If the black man was not a slave, what was he? A ward of the government, or a citizen? He could hardly be a ward, since a great many thousands of him had worn the government's uniform, carried its weapons, and taken a part in its battles; but if he was a citizen, was he a real citizen, or merely a second-class citizen? For a time the effort was made to admit him to full citizenship, but the business was just too much work. Only a minority really believed in it; the rest, who dimly wanted to see justice done, shied away from the day-by-day consequences of complete justice, and consented finally to the creation of a second class of citizenship for men and women so unfortunate as to be born with dark skins.

Yet something that came out of the Civil War made it impossible for the thing to rest there. Second-class citizenship is not a concept to which we take kindly, in this country. It is not, in the long run, a concept which can well endure—because the human race just is not made that way. This Other Man whose skin is not like mine: he is either an inferior being whom I can possess and whom I can compel to do my bidding, or he is a man, entitled to every right that I am entitled to. There is no handy half-way ground between those two points. By force of arms—by the intangible values that arise from half a million soldiers' graves—we determined, once and for all, that he is no longer to be a slave. So what do we do now?

It is that "what do we do now?" that is the current challenge left to us by the Civil War. The fact that we have not solved

the problem—have hardly even begun to grapple with it honestly—is the profound piece of unfinished business which we get out of the terrible war which almost tore the country apart nearly a century ago. Its existence is why we have to say that the Civil War was a beginning rather than an ending.

For the Civil War, whatever it cost us—however much tragedy it visited upon the nation, however much bitterness and misunderstanding and loss it left as its heritage—did at least commit us to the attempt to solve the race problem. And that effort, when you stop to think about it, is as lofty an effort as any people ever was called upon to attempt.

Put at its simplest, it is nothing less than an avowal that we believe in the brotherhood of man and are determined that we will eventually find some way to put it into actual practice.

It is not a matter of North versus South—not any longer. If, in the North, there were no longer any trace of racism: if in the North there were no places where a human being's attempt to make the most he can out of his life is hampered and brought to nothing by the fact that his skin is darker than most men's skins are—then we who come from the North might perhaps assume a holier-than-thou attitude and indulge in pious preachments to our friends in the South. But we have not got to that point. Nothing at all is to be gained by a blanket indictment of Southerners as people who have failed to grasp the true significance of the Civil War.

We have all failed to grasp it. It was not a closed chapter in a bloody book of history: it was a commitment, a challenge to

everything that we believe in and live by, a point from which we must measure our progress within our own hearts. Let us begin by understanding just what was bought by that tragic expenditure of life and hope, ninety-odd years ago. Let us try to see just what sort of door into the future was flung open by that fearful war between brothers. Then let us try to make the most of what was gained.

For the enduring legacy of the Civil War is an unending challenge; a challenge to the world's greatest democracy to establish itself on a foundation so broad and solid that it will endure through the great world upheaval of the twentieth century. Democracy will survive only if it lives up to the promise that was inherent in its genesis. The fulfillment of that promise is in our keeping.

# Index

# Index